EUROPE

44	Geiranger Fjord - Norway	56	Stonehenge - ENGLAND	111	Paris - FRANCE	81	Black Forest - Germany	106	Tuscany - ITALY
138	Stockholm - sweden	68	Dingle Peninsula - IRELAND	118	Antibes - FRANCE	64	Prague - CZECH REPUBLIC	86	Colosseum - mary
112	Copenhagen - Denmark	60	Giant's Causeway - Northern Ireland	62	Mont Blanc - FRANCE, ITALY & SWITZERLAND	125	Vienna - Austria	32	Acropolis - Greege
108	Isle of Wight - ENGLAND	66	Barcelona - spain	93	Lake Lucerne - switzerland	124	Budapest - HUNGARY	40	The Cyclades - Greece
41	Lake District - England	136	Andalusia - spain	69	Bruges - Belgium	104	Dubrovnik - croatta	78	Tallinn - ESTONIA
94	London - ENGLAND	114	Lot - FRANCE	54	Amsterdam - NETHERLANDS	37	Venice - maly		
		-			the second				

ASIA

CHINA

Angkor Wat 38

34 Gre

57 Hong Kong

82 Guili

Phan Th

Bali NESIA 48

120

at Wall of Chin

3

92

102 Maldives

EUROPE

62 Ista ISOleum of Antiochus 72 Mai TURKEY An Sea of Galilee 74 80 Petra JORDAN Great Pyramid 76 EGYPT Abu Simbel 50

AFRICA

42

elands 133

58 126 Mount Kilimanjaro TANZANIA 90 Seychelles

84 Okavango Delta NAMIBIA

OUTH

53 Madagascar

TSWAN

Mamanuca Islands 67 Great Barrier Reef

4 Australian Outback **AUSTRALIA**

103 **Jigokudani** Japan

75 Kyoto

100 Sydney Harbor

New Zealand (

Tasmania 🥺

Heaven on Earth

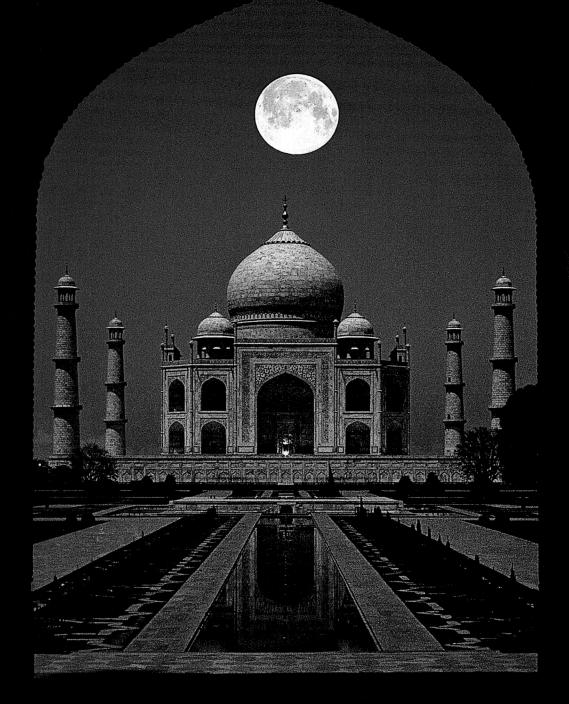

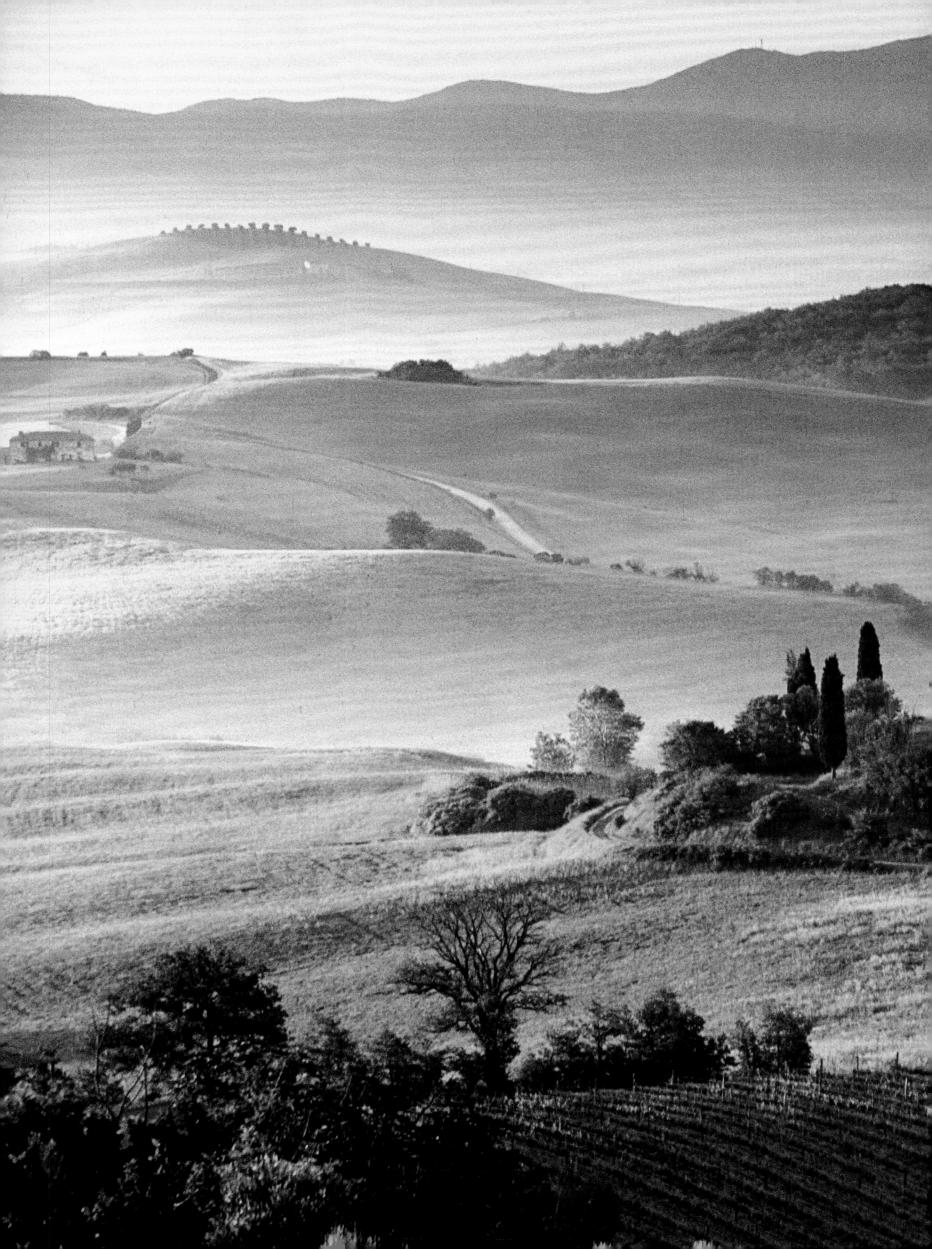

Heaven on Earth

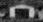

HEAVEN ON EARTH Editor Robert Andreas **Director of Photography** Barbara Baker Burrows Creative Director Mimi Park Deputy Picture Editor Christina Lieberman Writer-Reporter Hildegard Anderson Copy Wendy Williams (Chief), Kathleen Berger, Lesley Gaspar, Parlan McGaw, Production Manager Michael Roseman Assistant Production Managers Leenda Bonilla, Rachel Hendrick Production Coordinator Maryl Swick Photo Assistant Joshua Colow

Consulting Picture Editors Suzanne Hodgart (London), Mimi Murphy (Rome), Tala Skari (Paris) Special thanks to Judy Fayard (Paris)

LIFE Books Managing Editor Robert Sullivan President Andrew Blau Business Manager Roger Adler Business Development Manager Jeff Burak

TIME HOME ENTERTAINMENT Publisher Richard Fraiman

General Manager Steven Sandonato Executive Director, Marketing Services Carol Pittard Director, Retail & Special Sales

Tom Mifs **Director, New Product Development**

Peter Harper Director Bookazine Marketing Laura Adam **Publishing Director, Brand Marketing** Joy Butts

Assistant General Counsel Helen Wan Book Production Manager Suzanne Janso Design & Prepress Manager helle Galle

Brand Manager Roshni Patel Associate Production Manager Brynn Joyce

Editorial Operations Richard K. Prue (Director), Brian Fellows (Manager), Keith Aurelio, Charlotte Coco, Tracey Eure, Kevin Hart, Mert Kerimoglu, Rosalie Khan, Patricia Koh,Marco Lau, Brian Mai, Po Fung Ng, Rudi Papiri, Robert Pizaro, Barry Pribula,Clara Renauro, Katy Saunders, Hia Tan, Vaune Trachtman

Special thanks to Christine Austin, Jeremy Biloon, Glenn Buonocore, Jim Childs, Susan Chodakiewicz, Rose Cirrincione, Jacqueline Fitzgerald, Carrie Frazier, Lauren Hall, Malena Jones, Mona Li, Robert Marasco, Kimberly Marshall, Amy Migliaccio, Brooke Reger, Dave Rozzelle, Ilene Schreider, Adriana Tierno, Alex Voznesenskiy, Vanessa Wu

Copyright © 2011, 2006 Time Home Entertainment Inc.

Published by LIFE Books an imprint of Time Home Entertainment Inc. 135 West 50th Street New York, New York 10020

All rights reserved. No part of this book may be reproduced in any form or by any electronic or mechanical means, including information storage and retrieval systems, without permission in writing from the publisher, except by a reviewer, who may quote brief passages in a review.

ISBN 10: 1-60320-137-8 ISBN 13: 978-1-60320-137-7 Library of Congress Control Number: 2005908817

"LIFE" is a registered trademark of Time Inc.

We welcome your comments and suggestions about LIFE Books. Please write to us at: LIFE Books Attention: Book Editors PO Box 11016 Des Moines, IA 50336-1016

If you would like to order any of our hardcover Collector's Edition books, please call us at 1-800-327-6388.

(Monday through Friday, 7:00 a.m.—8:00 p.m. or Saturday, 7:00 a.m.—6:00 p.m. Central Time).

GE 1: The Taj Mahal Larry Burrows PAGE 2-3: Tuscany Peter Adams/Getty THESE PAGES: Mount Kilimanjaro Tim Davis/Corbis

6 Introduction

America 8

- The Grand Canyon 8
- Katmai 10
- 11 Kauai
- Lake Tahoe 12
- Nantucket 13
- 14 **Big Sur**
- Acadia 16
- 17 Charleston
- 18 Denali
- **Monument Valley** 19
- Hoh Rainforest 20
- The Great Smoky Mountains 22
- The Florida Keys 23 **Mount Rushmore** 24

24 The San Francisco Bay Area

- 26 Yellowstone
- Natchez Trace 28
- 29 Mammoth Cave
- Yosemite 30
- The Statue of Liberty 31

The World 32

- 32 The Acropolis
- The Great Wall of China 34
- The Galápagos Islands 35
- 36 South Georgia Island
- Venice 37 38
- Angkor Wat The Cyclades 40
- The Lake District 41

- 42 The Namib Desert
- The Amazon 43
- **Geiranger Fjord** 44
- 46 Easter Island
- The Australian Outback 47 48
 - Bali
- St. Petersburg 49
- Abu Simbel 50
- 52 Iguaçu Falls
- Madagascar 53
- 54 Amsterdam
- 55 56 Belize
- Stonehenge
- Hong Kong 57 58
- The Serengeti 60 The Giant's Causeway
- **New Zealand** 61

- Istanbul 62 62 Mont Blanc
- Prague Barcelona 64 66
- 67 The Great Barrier Reef The Dingle Peninsula
- 68
- 69
- Bruges Torres del Paine 70
- Bhaktapur 72
- 72
- The Mausoleum of Antiochus The Sea of Galilee 74
- Kyoto
- The Great Pyramid
- 75 76 78 Tallinn
- Rio de Janeiro
- 79 80 Petra
- **The Black Forest** 81

84 The Okavango Delta Machu Picchu The Colosseum 85 86 Barbados 87 Iceland 88 The Seychelles Churchill 90 91

Guilin

82

- The Taj Mahal 92 Lake Lucerne 93 London
- 94 96 Bermuda
- Guadalajara 97
- The Potala Palace 98
- Tasmania 99
- 100 Sydney Harbor 102 The Maldives
- 103 Jigokudani 104 Dubrovnik 105 Buenos Aires Tuscany The Isle of Wight 106 108 109 Monte Albán 110 Tikal 111 Paris 112 Copenhagen 113 Fez The Lot 114 116 Cartagena 117 Krabi 118 Antibes 118 Vancouver 120 Phan Thiet 122 Registan Square
- 122 Yamdrok Yumtso 124 Budapest Vienna 125 126 Mount Kilimanjaro 128 Quebec City 129 The Canadian Rockies 130 Bora Bora 132 Magdalena Bay 133 The Winelands 134 Cape Breton Island 136 Andalusia 137 The Mamanuca Islands 138 Stockholm 140 The Sahara 142 Vieques
 - 143 Just One More

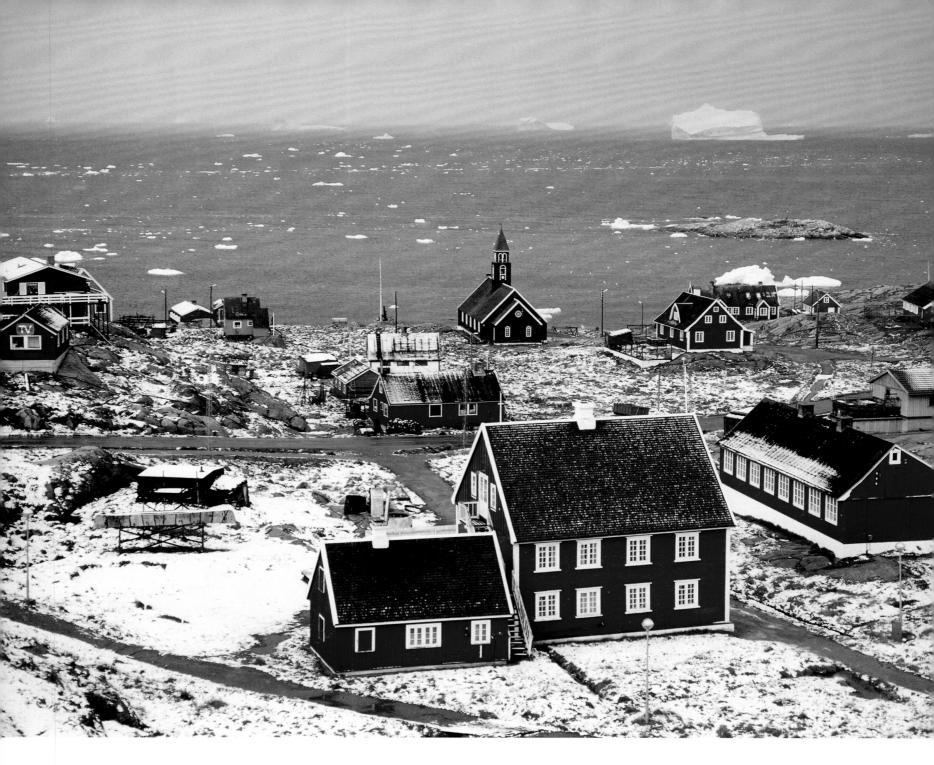

Introduction

he first step in the creation of this book was, naturally enough, determining which locations would make up the must-see destinations. We received candidates from friends and colleagues who had actually been on trips to dreamy places, and we received candidates from those who had dreamed of going on dream trips, and we accepted candidates from those who had heard about people who had been on dream vacations.

We did extensive research, and we looked (with no little sense of wonder) at other books—contemporary, historic, even ancient—that had been done on similar topics.

The first lesson we learned is that there are a lot of places that are definitely worth going to.

We decided that a destination such as the summit of Mount Everest was without doubt the trip of any lifetime, but how many people could actually make it up there? Even getting to base camp is no easy matter. None of the people making this book were, under any circumstances, going to scale Everest, so we decided that a trip beyond our remarkably ordinary physical capabilities would have to be ruled out.

We also decided that the purpose of this book was not to hew to any one pursuit. That is, if a place is good only for hiking or shopping or golfing or boating or collecting rare insects, then it would not qualify. There needed to be at least some broader level of attraction.

Another necessary criterion was the photography. This is, above all, a picture book, and if we couldn't get what we considered a great picture— one that also wasn't achingly familiar—then that site would not be appropriate for this book.

Even having established these and sundry other ground rules, we still had a tiger by the tail. There were so many destinations worthy of inclusion that winnowing them out was dicier than we had expected. Many had their own ardent champions; just as many had equally firm naysayers. Perhaps half the choices weren't that complicated. Big Sur, Tuscany, Kyoto . . . they There are many places that might have merited inclusion but, for one reason or another, did not make our list. Clockwise from right: an abbey in a field of lavender in the French region of Provence; a stretch of the Pacific at La Jolla, Calif.; a village on the coast of Greenland.

were going to make the cut. We can only hope that our final list meets with your satisfaction, or at least does not incur your wrath if a place you hold dear in your heart has, inexcusably, been omitted.

As for the ordering of the destinations, we weighed the various options. They might have been grouped by continent, or by type—cities here, beaches there—but we decided that this is not how people travel. They don't finish South America and then move on to Asia. They don't do the cities and then the ruins. They go to whatever place holds the most interest for them at the moment. Thus we hope that in leafing through these pages some inspiration may be ignited that might otherwise have never been kindled.

So, here they are, with America first, and then the rest of the world . . . with just one more tagged on at the end for good measure. Bon voyage!

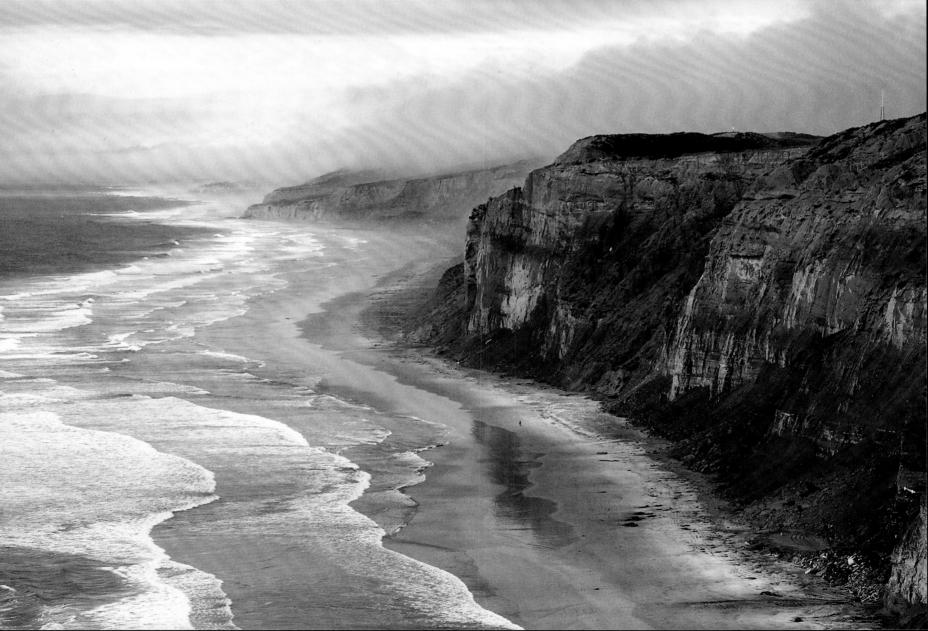

Μ

E

R

C

A

A

Granted, there are crowds. But when at last one approaches the edge of this massive composition—born two billion years ago of tectonic mayhem, water, erosion and deposition—it is impossible not to be thunderstruck by the awesome sights laid out on such an epic scale. In a word, incomparable.

EGrand Canyon

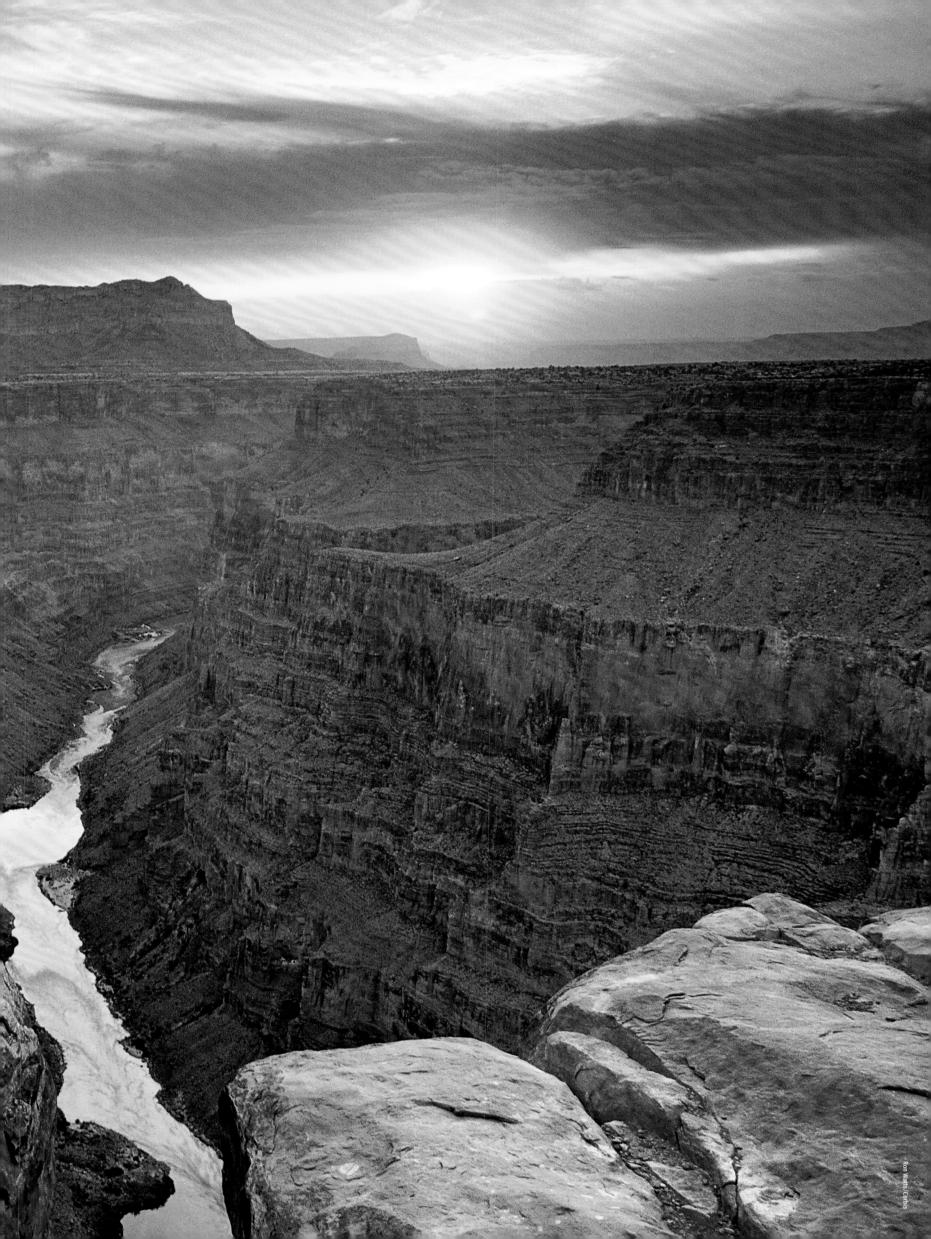

his national park is located in southwest Alaska, and these words from its first superintendent, Gilbert E. Blinn, need no embroidery: "It is a land of uncrowded spaciousness, a place where people can experience wilderness on its own terms without the distraction of hordes of other visitors. It is a place where time and change are measured by the sun, the tides and the seasons rather than clocks and calendars."

Kauai

There are, certainly, resorts and golf and all that sort of thing, but what places this Hawaiian island a cut above the others is its combination of fabulous beauty think waterfalls everywhere—and fewer tourists. Sea cliffs, grottoes, jagged mountains, Pacific beaches and the astonishing Waimea Canyon are some of the reasons for Kauai's nickname: the Garden Isle.

Lake Tahoe

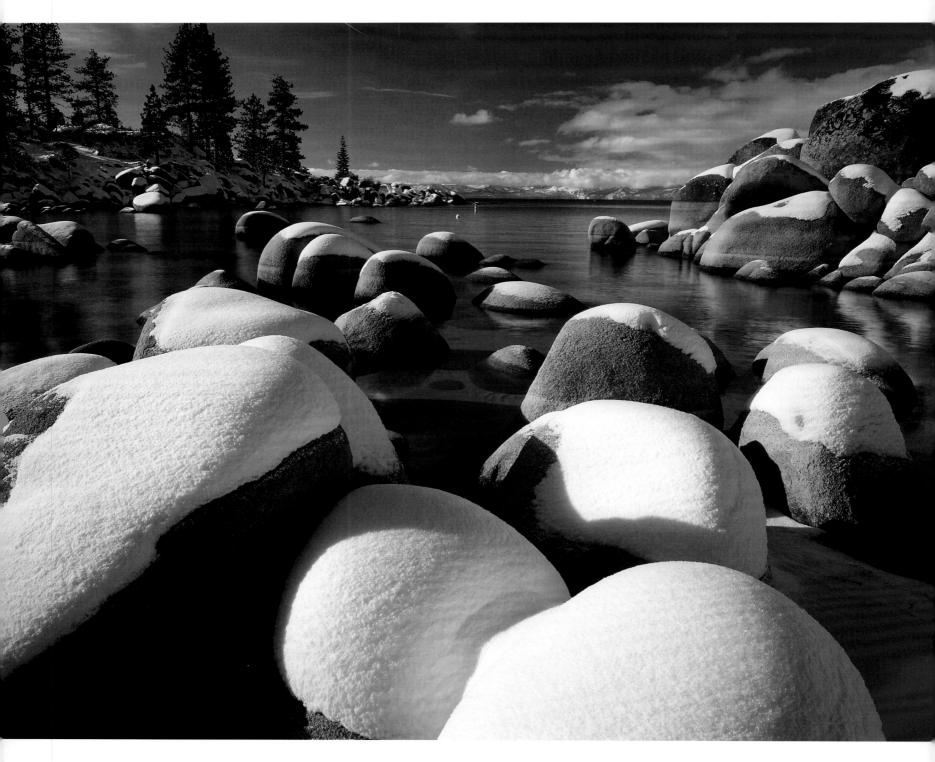

David Muench/Corbi

This alpine lake on the California-Nevada border is a glistening attraction every month of the year. During warm times, with its surrounding ring of snowcapped peaks, it is a mecca for walkers and cyclists, while its extraordinarily clear waters and breathtaking beaches keep bathers more than happy. In winter, the skiing is sensational. And for the more sedentary, there is the clarion call of casinos on the Nevada side.

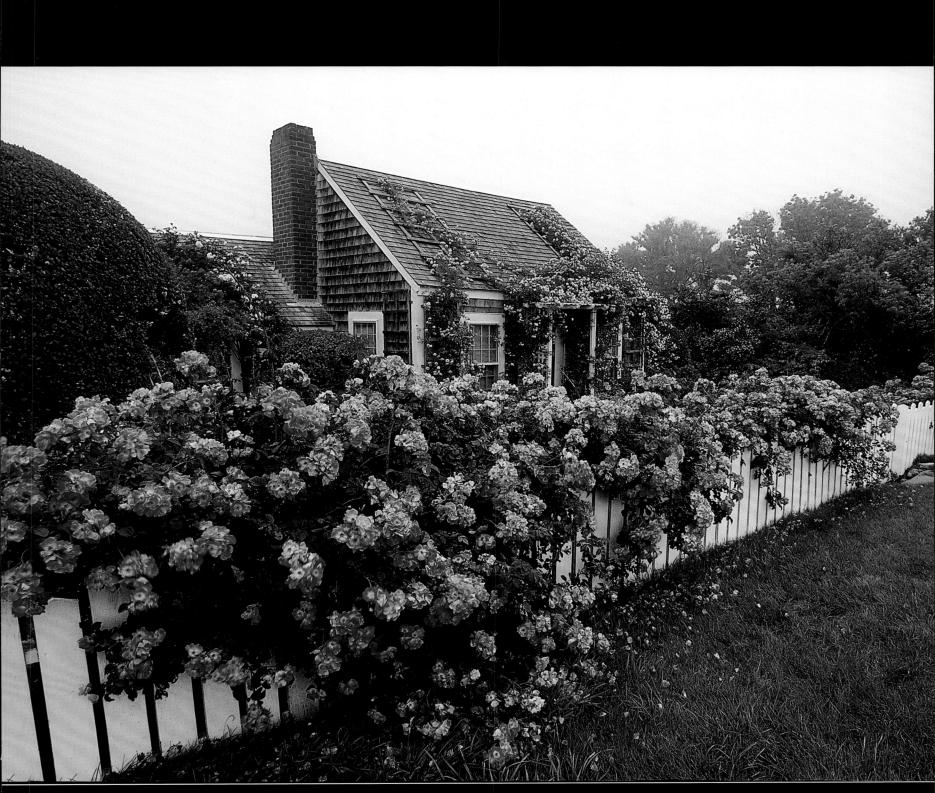

Nantucket

Perhaps the most charming place on earth, this little becottaged island 26 miles off Cape Cod steals the heart of all who

Big Sur

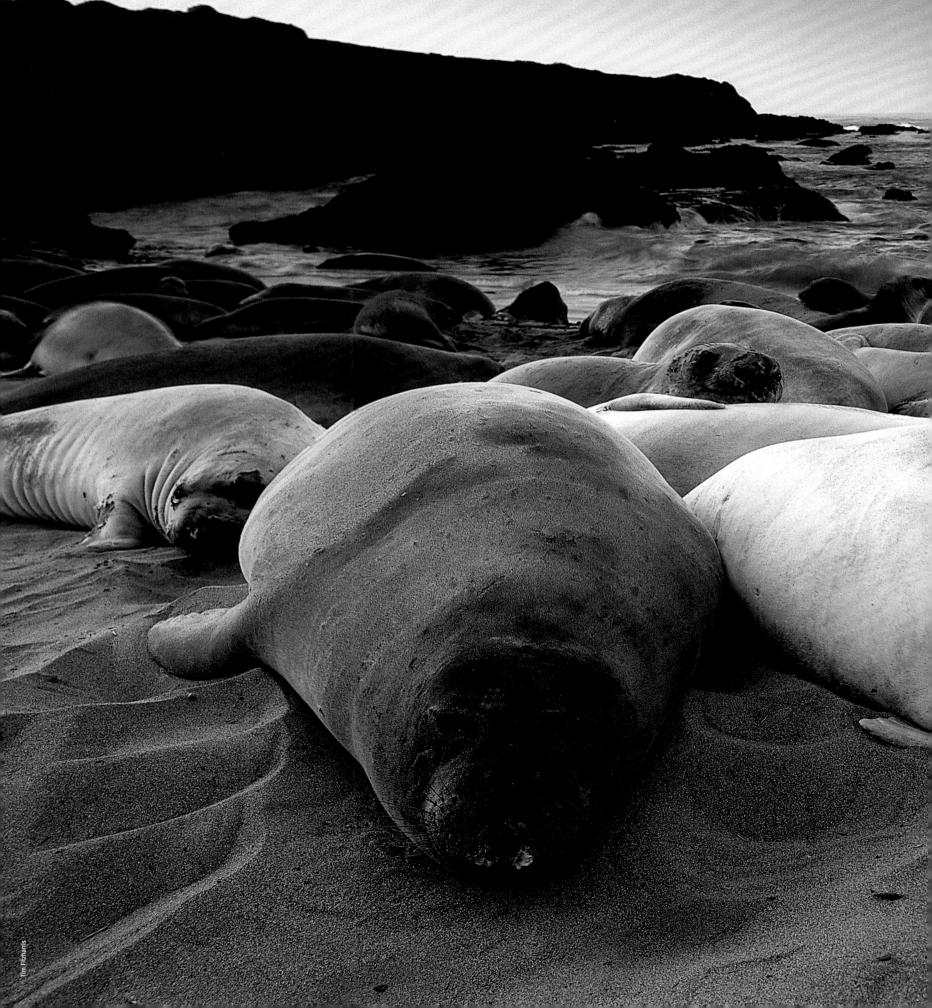

There is a stretch of Highway 1 in California about a hundred miles long that is, for many, the most awesome place anywhere. On one side forest and mountains rise up to the sky, while on the other the Pacific Ocean stages a dizzying series of ravishing tableaux. Miraculously, the area has endured a minimum of development, though there are a few excellent places to eat and sleep. This one is a must.

Acadia

Charleston

ne of the bastions of old Southern culture, this South Carolina city on the Atlantic has been hit by war, fire, hurricane, as well as other calamities, but survives as one of America's grandes dames. Picture-perfect streets and courtyards are host to Colonial homes and churches, while Charleston's parks and gardens are widely celebrated for their exquisite designs.

A ine's rocky, evocative shoreline merges potently with spiky stands of evergreens and granite-domed mountains in the first site east of the Mississippi to be deemed a national park. There may be no other locale in the country that is so pleasingly defined by rusticity.

David Muench/Corbis

Denali

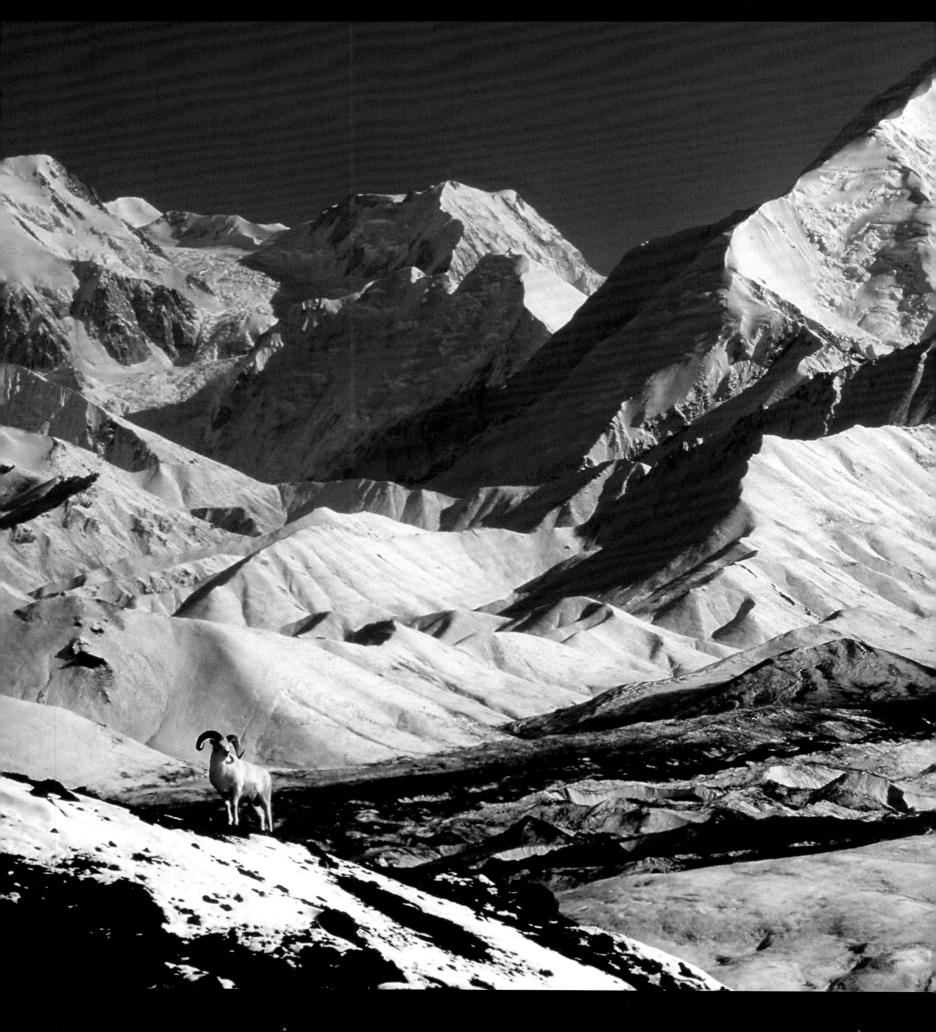

Nearly half the total acreage of America's national parks is in Alaska, which will surprise no one who has been to the 49th state. For decades, Denali was the only such park, a signal distinction. The name is from the native Athabaskan term meaning "the high one," perhaps a reference to Mount McKinley, North America's highest peak. In the summer there are everywhere radiant visions, and wildlife on an epic scale.

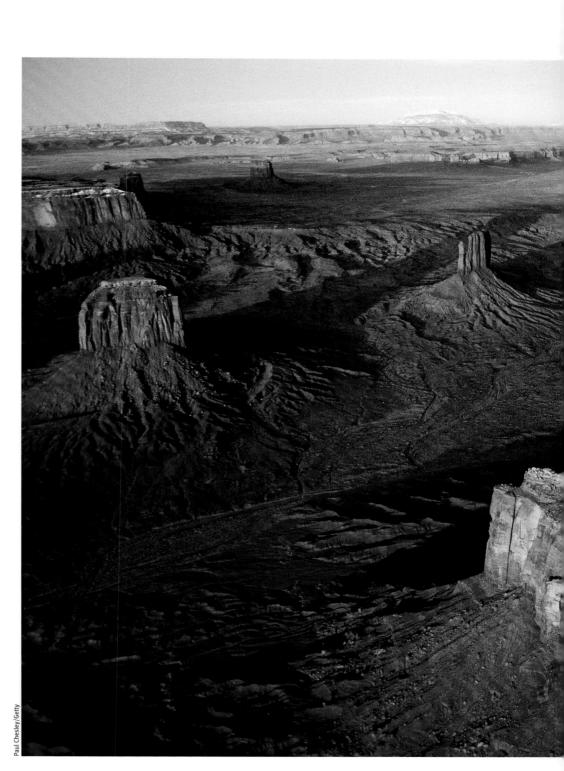

his is does of

N o other place so says "This is the American West!" as does this 2,000-square-mile section of Arizona and Utah, which is not a valley at all but a wide, flat landscape of red buttes, spires, mesas and arches. Think of the sublime scenery in John Ford's classic western films and you'll understand why it must be encountered in person.

Hoh Rainforest

t is very unusual to find a rainforest in a temperate climate, but the Olympic Peninsula, not very far from Seattle, has a classic example with Hoh. Warm Pacific winds passing over mountains are quickly cooled and turned into moisture. Marked by an unrivaled lushness, the hushed rainforest has life thriving in the canopy, at midlevel and on the floor.

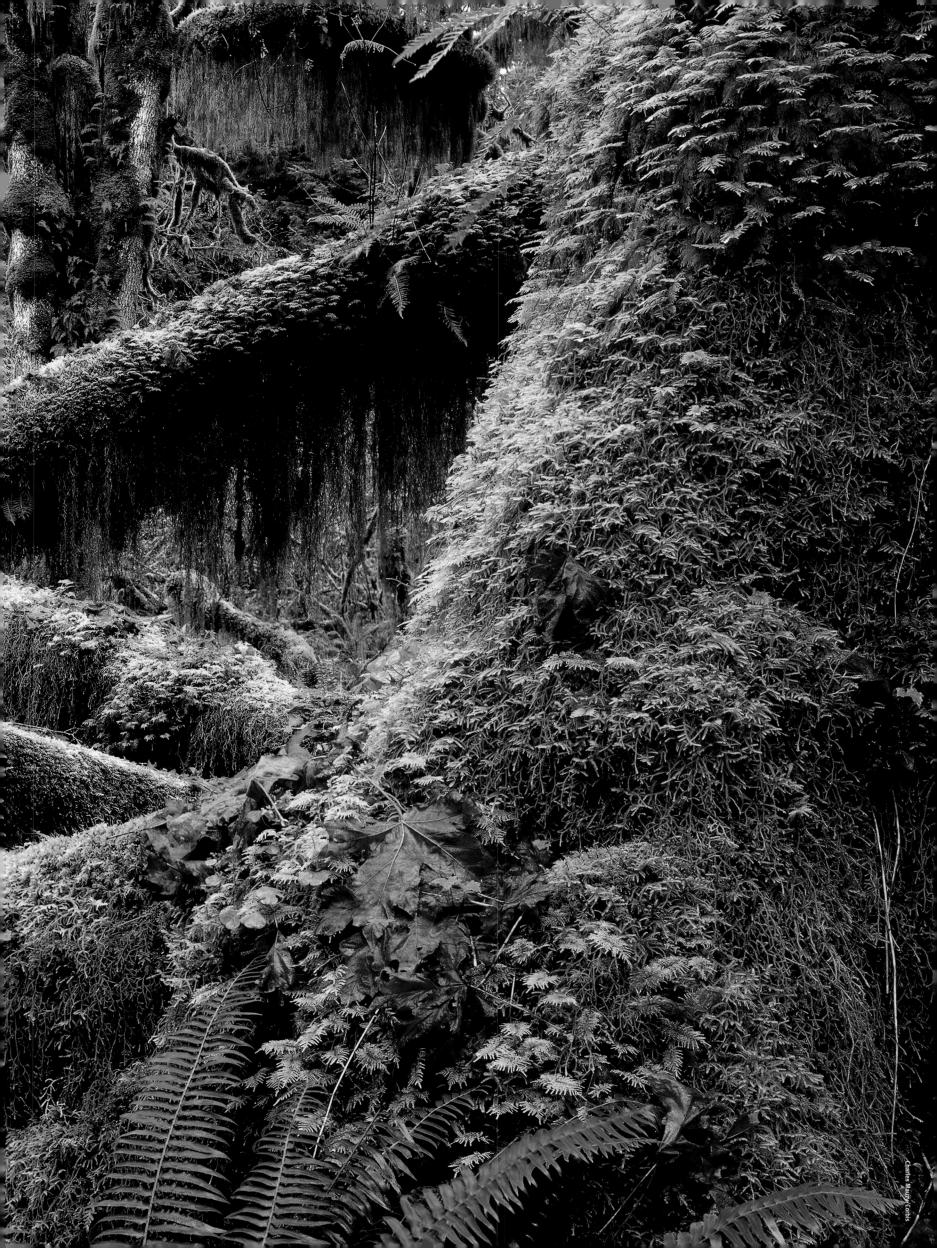

THE Great Smoky Mc NT2

S naking through North Carolina and Tennessee, these ancient hills have bequeathed some of the country's finest locales, including a 72-mile segment of the Appalachian Trail and, of course, the national park. The forestland is one fifth virgin growth—red maple, hickory, beech—and blessed throughout with pristine streams and a rich undergrowth.

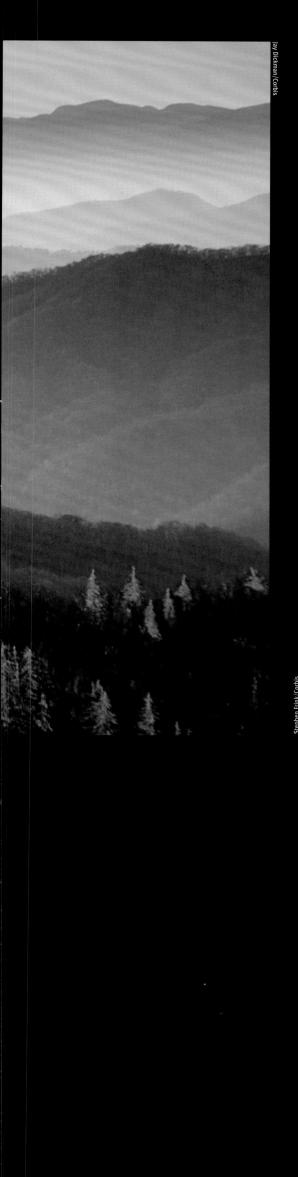

This 106-mile string of natural gems provides a thoroughly "other" feel, yet you don't have to exchange currency or get a visa because, amazingly, you're still in the States. From Key Largo out to Islamorada—the Sportfishing Capital of the World—to the terminus at Key West, where the sunset ignites an evening carnival, the Keys are a different world.

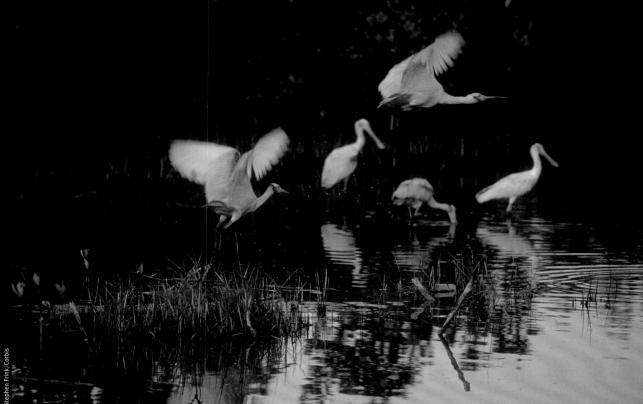

Florida Keys

Mount Rushmore

In 1924, Doane Robinson of the South Dakota Historical Society contacted the sculptor Gutzon Borglum about the notion of carving statues of western heroes like Buffalo Bill and Lewis and Clark into the Black Hills. Borglum became entranced but wanted to work on a national scale, thus the visages of four Presidents would be created, over a period of 14 years. A monument to America, on a scale that awes those beholding it.

he city itself is, famously, one the most exciting anywhere, sophisticated but with an undeniable air of the derring-do of the Old West. Just outside of town, though, are an abundance of places that anywhere else would be the sole focus of attention: Muir Woods, Mount Tamalpais, Lake Merritt, Sausalito, Tiburon and so many others—and only an hour away is the wine country.

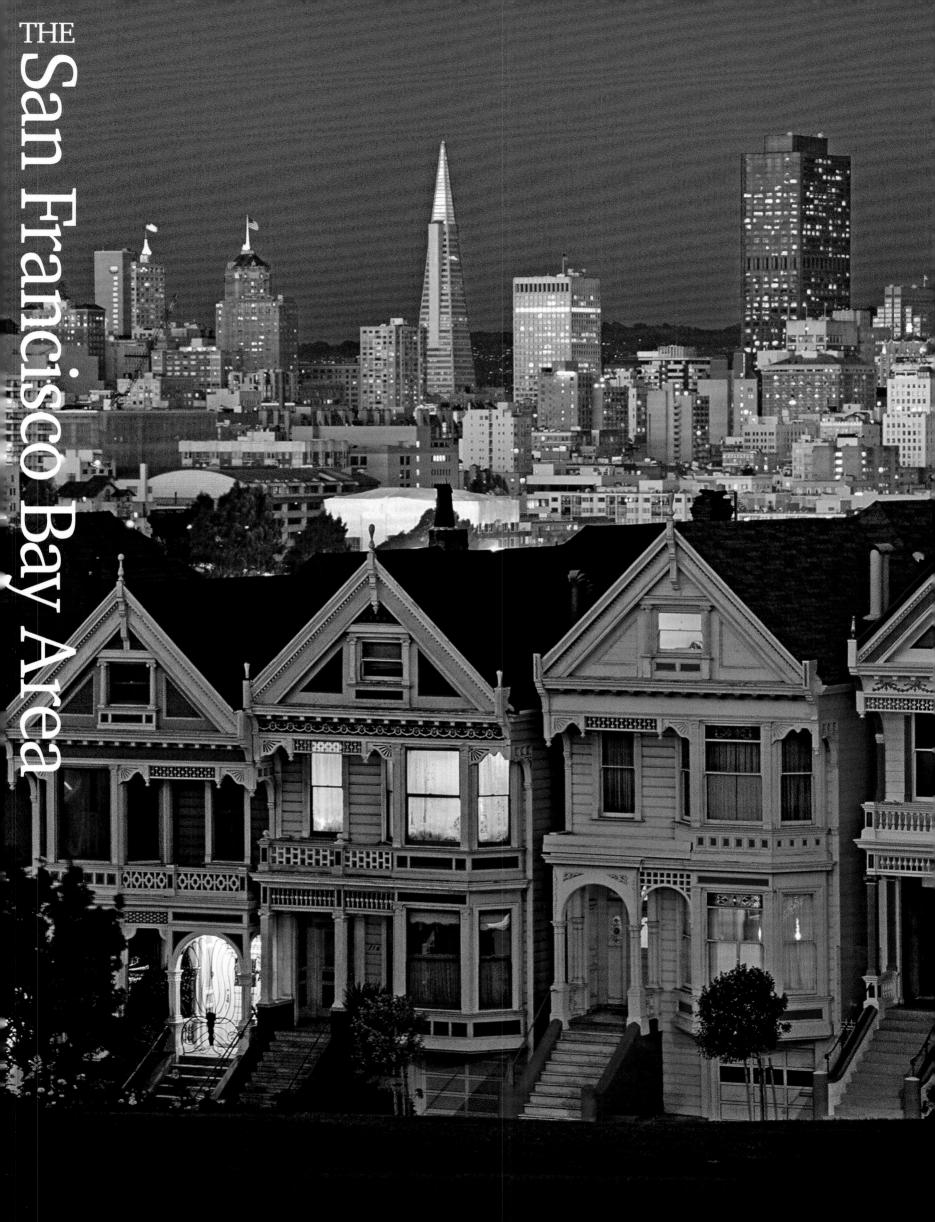

Yellowstone

The first national park anywhere in the world, Yellowstone is situated in Wyoming, Montana and Idaho, with an average elevation of 8,000 feet. Every 88 minutes Old Faithful performs for one and all, and there are more than 200 other geysers among its 10,000 hot springs. There are, as well, bison, bear and wolf, lakes, rivers and waterfalls, and fossil forests and fishing.

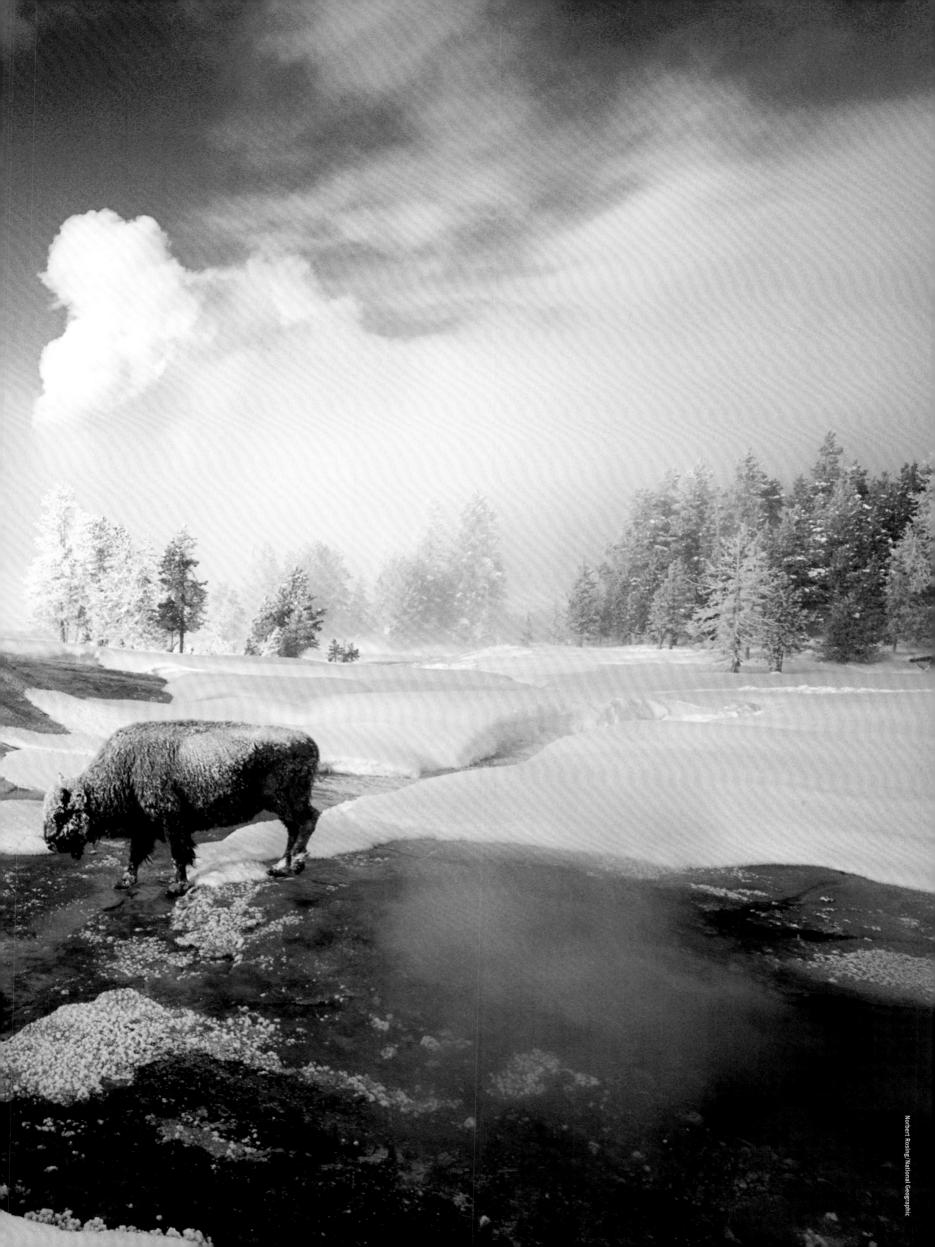

Natchez Trace

housands of years ago this trail was established by buffalo, and then Indians and trappers trod the path. By the late 1700s, the Trace had sprouted so many hazards, such as bandits, that it became known as the Devil's Backbone. Ironically, today this national parkway, which runs from Franklin, Tenn., to Natchez, Miss., has nothing to detract from its lush southernness: For 444 miles there are no gas stations, souvenir shops or fast food eyesores.

For those looking for something truly out of the ordinary, this eponymous national park in Kentucky delivers the goods. At 360 miles, it is three times longer than any other cave system in the world, and has an unrivaled array of geological formations and underground lakes and rivers. There are lighted paths, of course, and for the more daring a wild-cave tour is available.

An

XX

Yosemite

What an abundance of splendor! This central-California national park offers a trove of natural wonders, such as one of the most famous river valleys anywhere; El Capitan, the world's tallest unbroken cliff; Yosemite Falls; three sequoia groves; elaborate glacial features; and some 750 miles of maintained trails that meander amid 1,400 flowering plants and a profusion of birds and mammals.

11:424:21

his can be done two different ways. You can actually go to Liberty Island, step inside of Miss Liberty and ascend to her crown. Or you can just take a boat ride through New York Harbor and pass nearby her. Either provides a thrilling experience that any American, or any advocate of freedom and tolerance, will be ever grateful for.

24

Estatue of Liberty

AFF

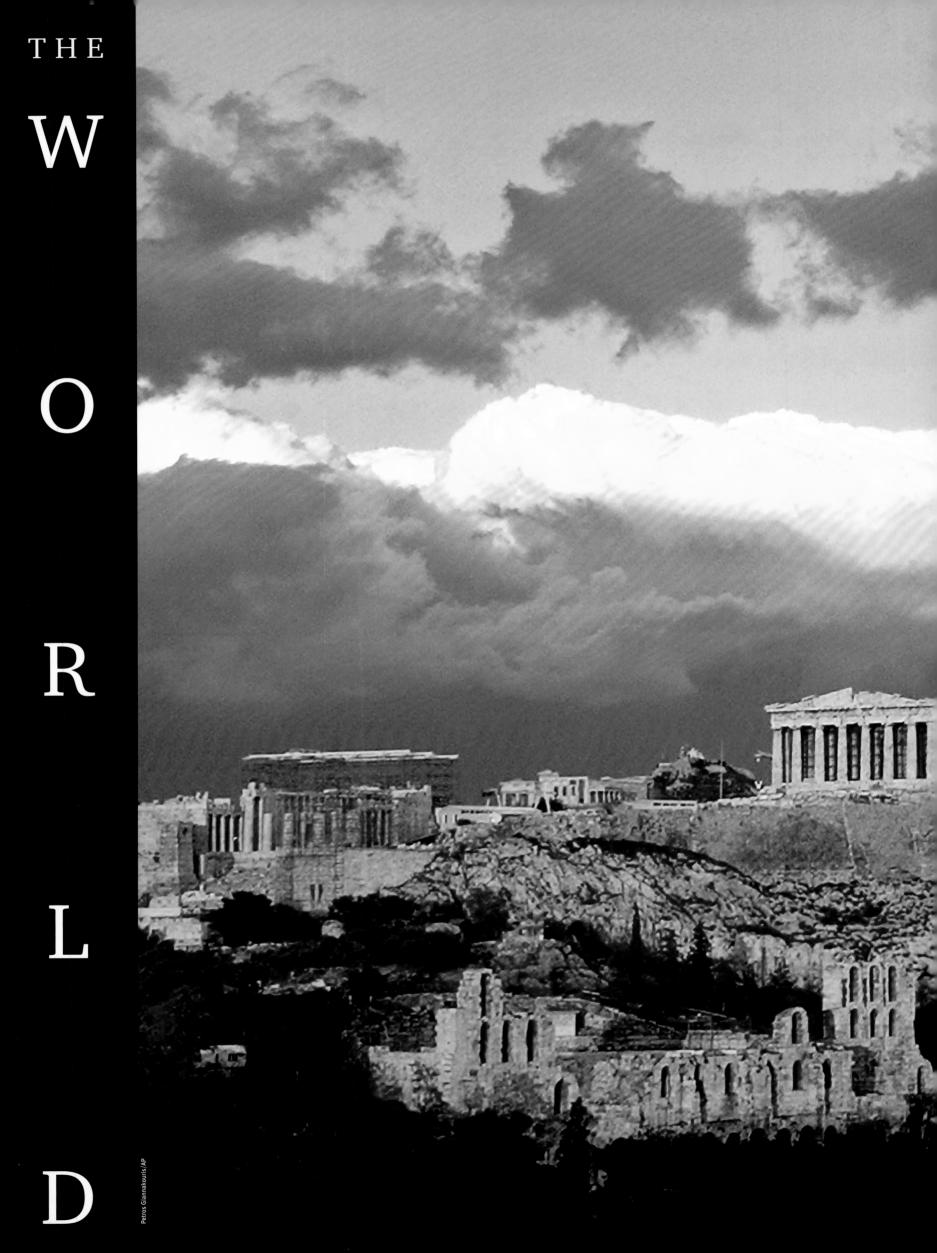

The attainments of ancient Greece perhaps mark the apex of human civilization, and the highest point in Athens itself is reserved for the Acropolis, built in the 5th century B.C. atop a craggy walled hill in honor of Athena, the city's patron goddess. There are four surviving structures, including the Parthenon. Here, time stands still, and glory abounds.

EAcropolis

Ereat Wall of China

The largest man-made thing on earth, it stretches like a palpable dragon for somewhere between 1,678 miles and 6,214 miles, depending how you measure it: There are loops and, in places, quadruple walls. By any measure it is one incredible barrier, nearly 20 feet wide at the base and 30 feet high. The Great Wall figures heavily in Chinese art and mythology.

Some 600 miles west of Ecuador may be found 19 isles that form a special place all its own. Charles Darwin first brought the archipelago to fame a century and a half ago, and since then countless visitors have come to see the famed tortoise, iguana, penguin and all the others that make this a bastion of uniqueness.

SUM

South Georgia Island

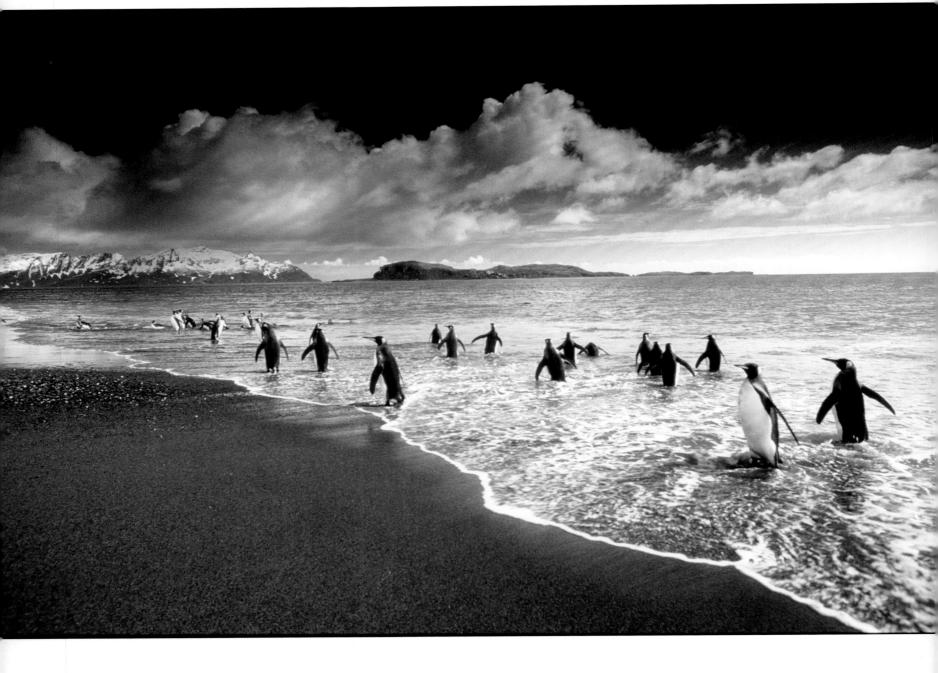

Some 1,300 miles east of the tip of South America, this subantarctic island is 100 miles long and 20 miles wide, and home to literally millions of seals, penguins and other seabirds, including half the world's population of wandering albatross. South Georgia is reachable only by water, but to behold this oasis on a glittering day may be the experience of a lifetime.

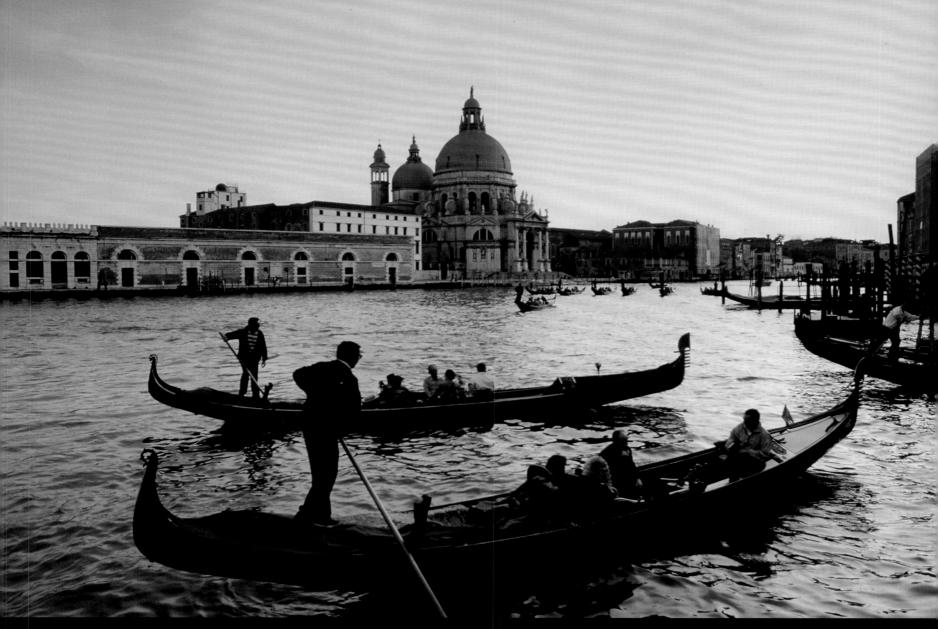

Venice

Bravely and crazily constructed on 118 islands within a crescentshaped lagoon, Venice is called La Serenissima – The Most Serene One. Once a trading center where East met West, the city has an extremely varied architecture, with unforgettable palaces, churches, St. Mark's Square, the Bridge of Sighs and a delirium of canals. Other than walking, the canals are the only way to get around, either by taxi or bus, or the romantic gondola.

The largest religious complex in the world, this archaeological and architectural treasure was built in the 12th century A.D. by King Suryavarman II in what was then the capital of the Khmer Empire, now known as Cambodia. The temple of Angkor Wat was dedicated to the Hindu god Vishnu, and the outer gallery walls contain the longest bas-relief in the world, a depiction of tales from Hindu mythology.

Angkor Wat

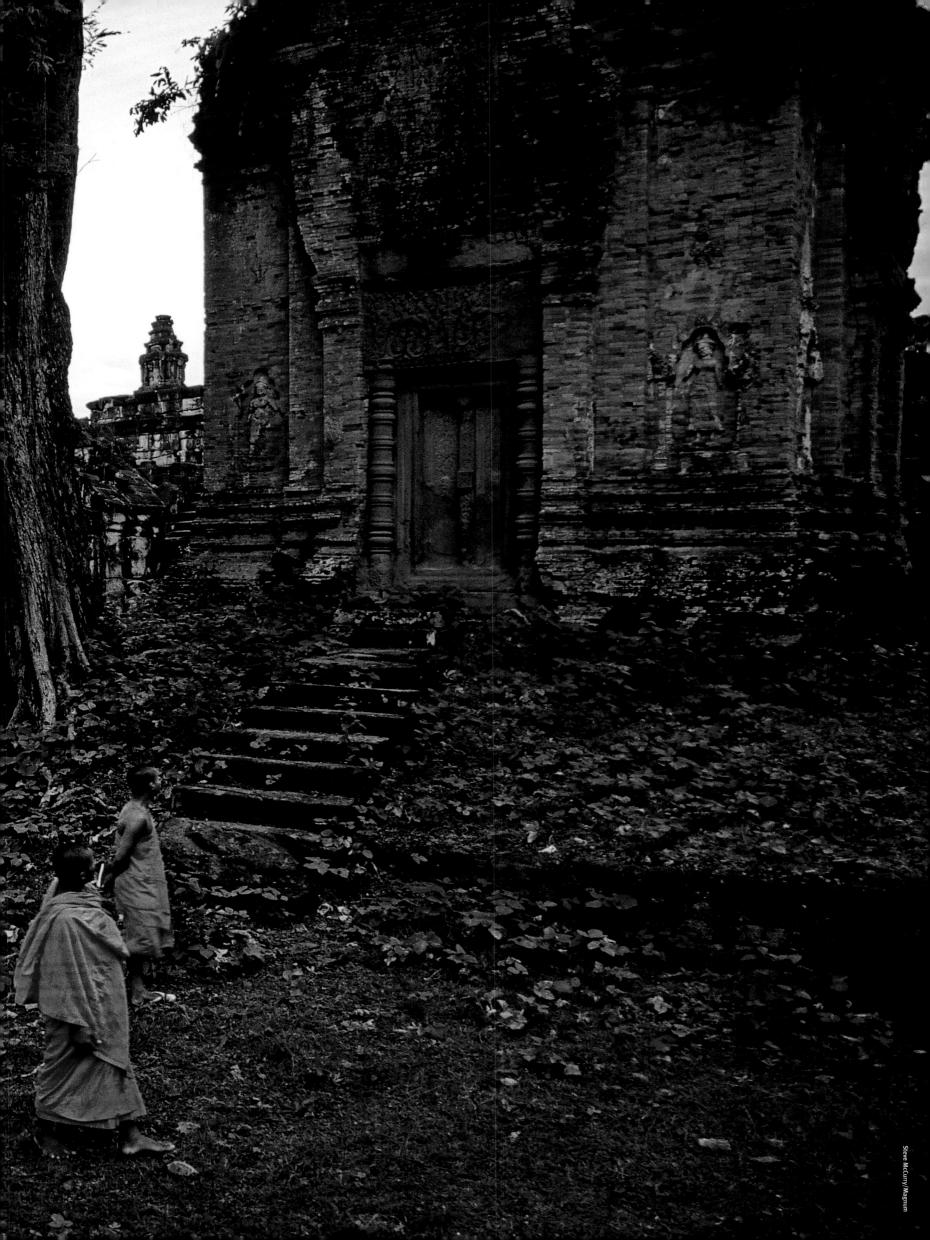

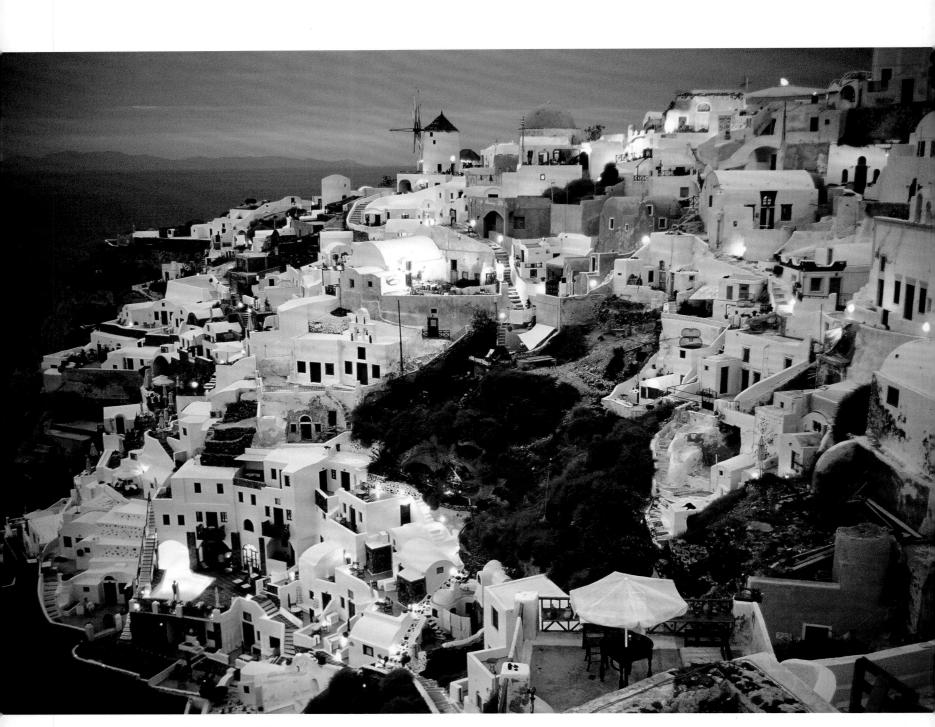

ECyclades

In antiquity these islands were at the center of a Bronze Age culture renowned for its white marble idols. Today the 30 or so isles that make up the Cyclades are famed still for their whiteness—as in their whitewashed villages juxtaposed breathlessly against the blue waters of the Aegean and its many white-sailed pleasure craft. Santorini (which is seen here), Mykonos, Delos, los . . . all of them blindingly beautiful.

Stuart Franklin/Magnur

ELake District

his fairy-tale section of northwest England first became familiar to many through the writings of Wordsworth, Coleridge and, later, Beatrix Potter. At 35 square miles it is not particularly large, but its appearance seems to change from moment to moment, locale to locale. One is ceaselessly won over by lakes and valleys, picturesque villages and isolated farmhouses that are set just so along the low craegy mountains

R nown as the oldest desert in the world, this transcendent environment is laid out in an ever-shifting geometry of lines forged by wind and sand. Found on the southwest coast of Africa, the desert covers 100,000 square miles and features mesmerizing dunes 20 miles long and one thousand feet high. Life in the Namib must rely on fog and dew for water.

ENamib Desert

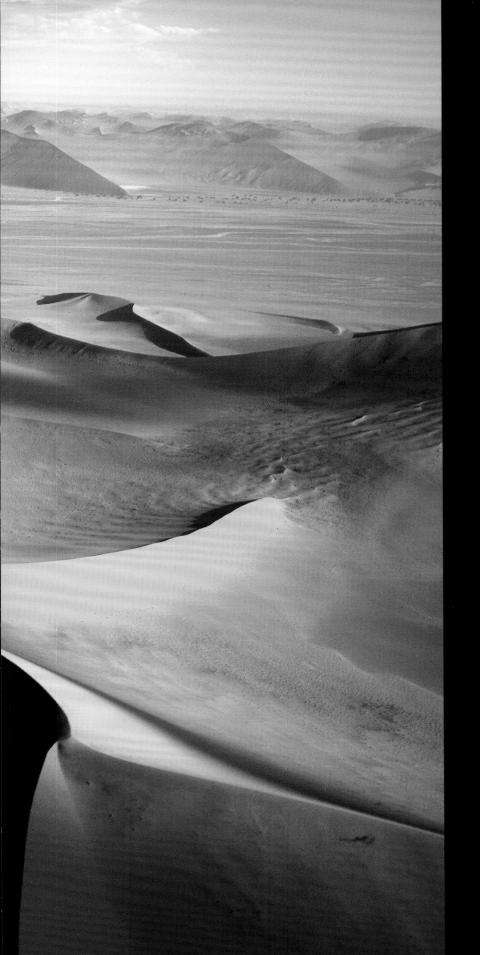

#Amazon

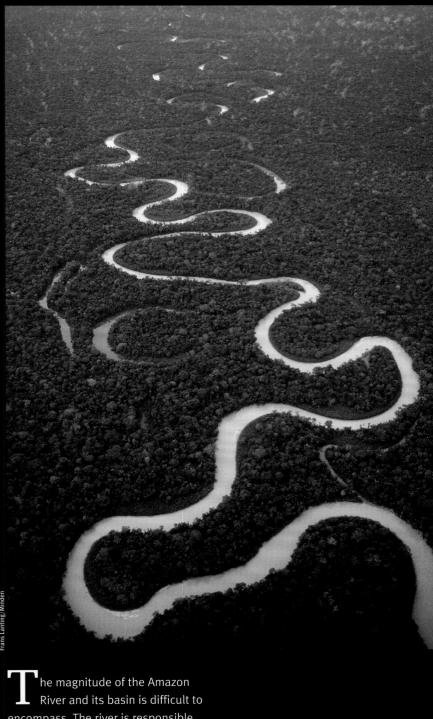

River and its basin is difficult to encompass. The river is responsible for one fifth of all the waters that are poured into the world's oceans. The rainforest in the basin houses hundreds of species of mammals, thousands of different fish, tens of thousands of trees, and a third of the planet's birds. One does not soon forget the Amazon.

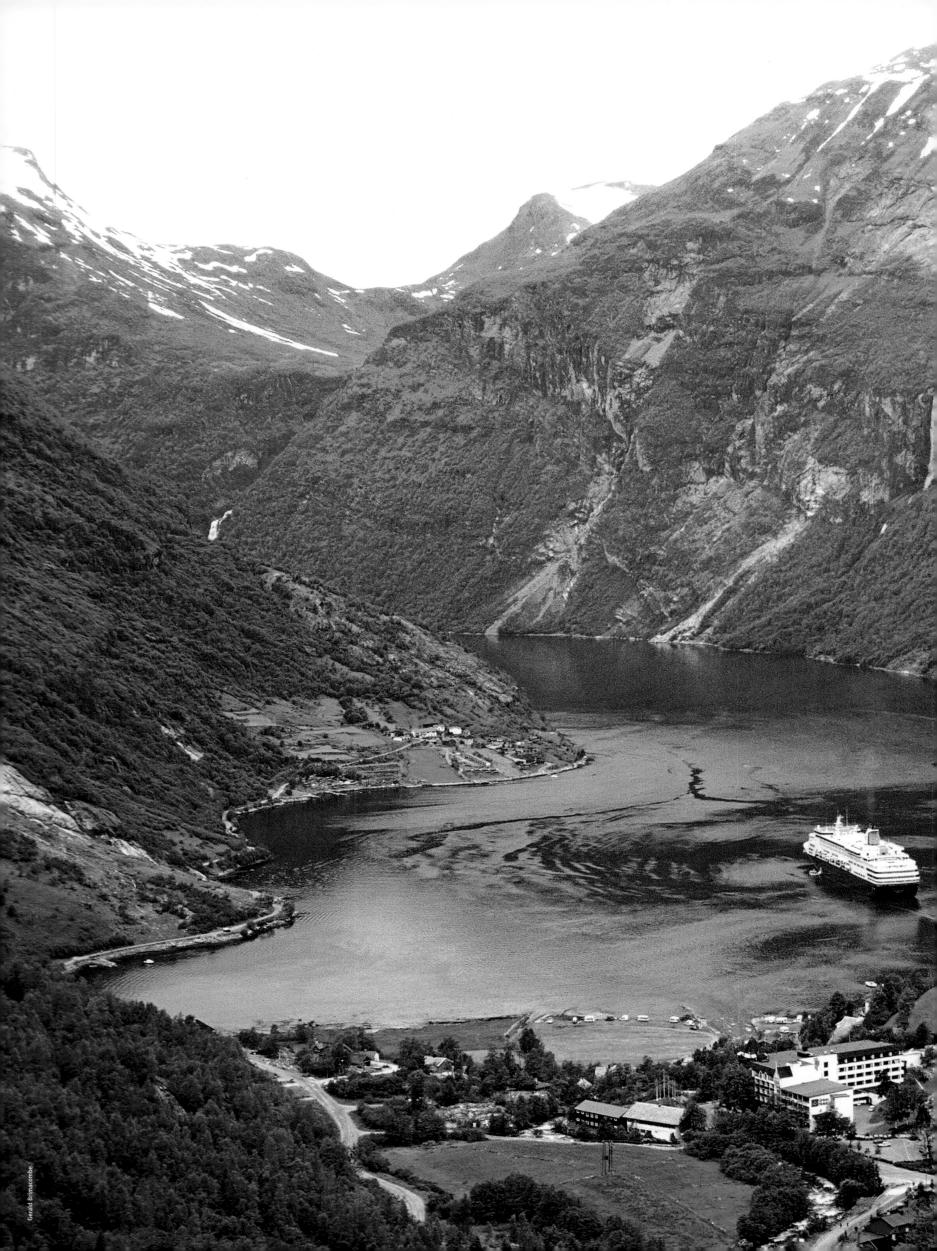

Geiranger Fjord

For those who have never had the pleasure, a fjord is a narrow sea inlet bordered by cliffs or steep slopes, and Norway's northern and western coasts are home to the world's most enticing. The 10-mile Geiranger is perhaps the most alluring, with its lovely waterfalls and high hills dotted with abandoned farms.

Easter Island

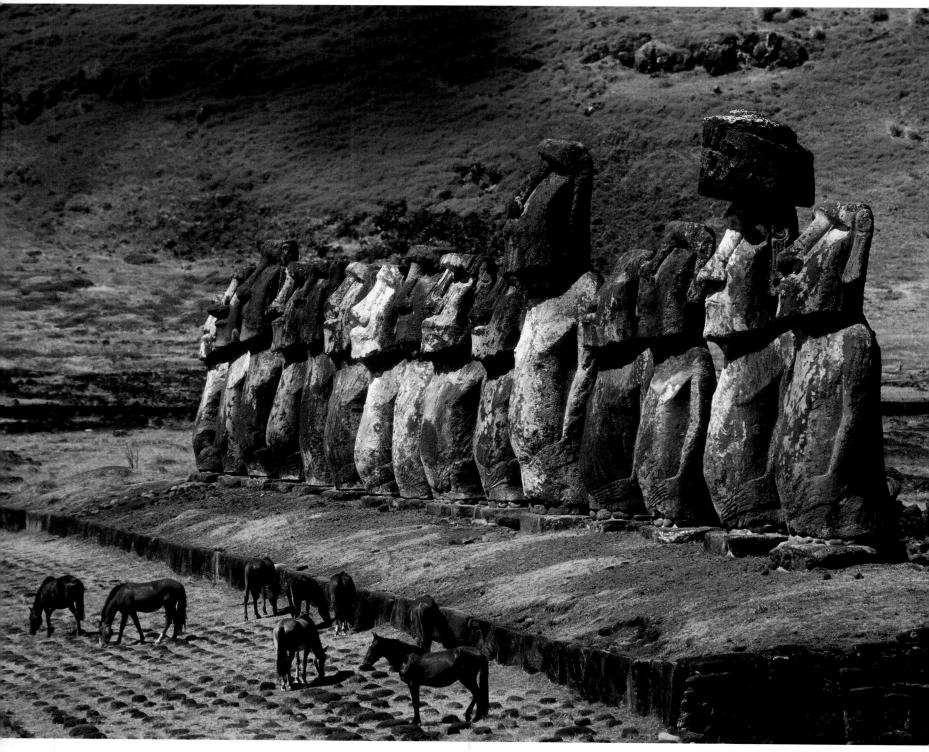

E quidistant from Chile and Tahiti, this remote outpost in the Pacific was settled in about 400 A.D. by Polynesians. Six hundred years later their descendants, for some reason, began to create and site giant statues, an enterprise that would eventually destroy the culture, as all the trees were cut down and used to move the statues, making it impossible to build boats to catch food. The island is still today a masterwork of enigma and mystery. The Outback—a.k.a. "back of beyond" and "never-never land" refers to most of the land apart from the continent's population centers. It is a very dry region, and its blue skies provide a brilliant backdrop for the land's reds and ochers. Kangaroos, emus and the world's only wild camels are common sights. The Outback is the last area where Australian Aboriginals sustain their ancient ways.

Australian Outback

Bali

Founded in 1703 by Peter the Great, this metropolis was built on the delta of the Neva River and laid out in the geometric manner of western Europe rather than the traditional Russian burgs that preceded it. Even though it has seen more than its share of turbulence — especially during its communist stint as Leningrad — it remains a most disarming city, with a wealth of attractions such as the Hermitage and the Summer Garden and Palace.

St. Petersburg

A Triffe

APPENDING FOR FREEM

G arved out of a sandstone cliff on the Nile in Aswan, Abu Simbel was built by the Egyptian pharaoh Ramses II, whose reign ended in 1213 B.C. There are two temples, and several attendant statues nearly seven stories tall. In the 1960s, a remarkable international engineering endeavor raised the temples by 200 feet to protect them from elevated waters resulting from the Aswan High Dam.

4

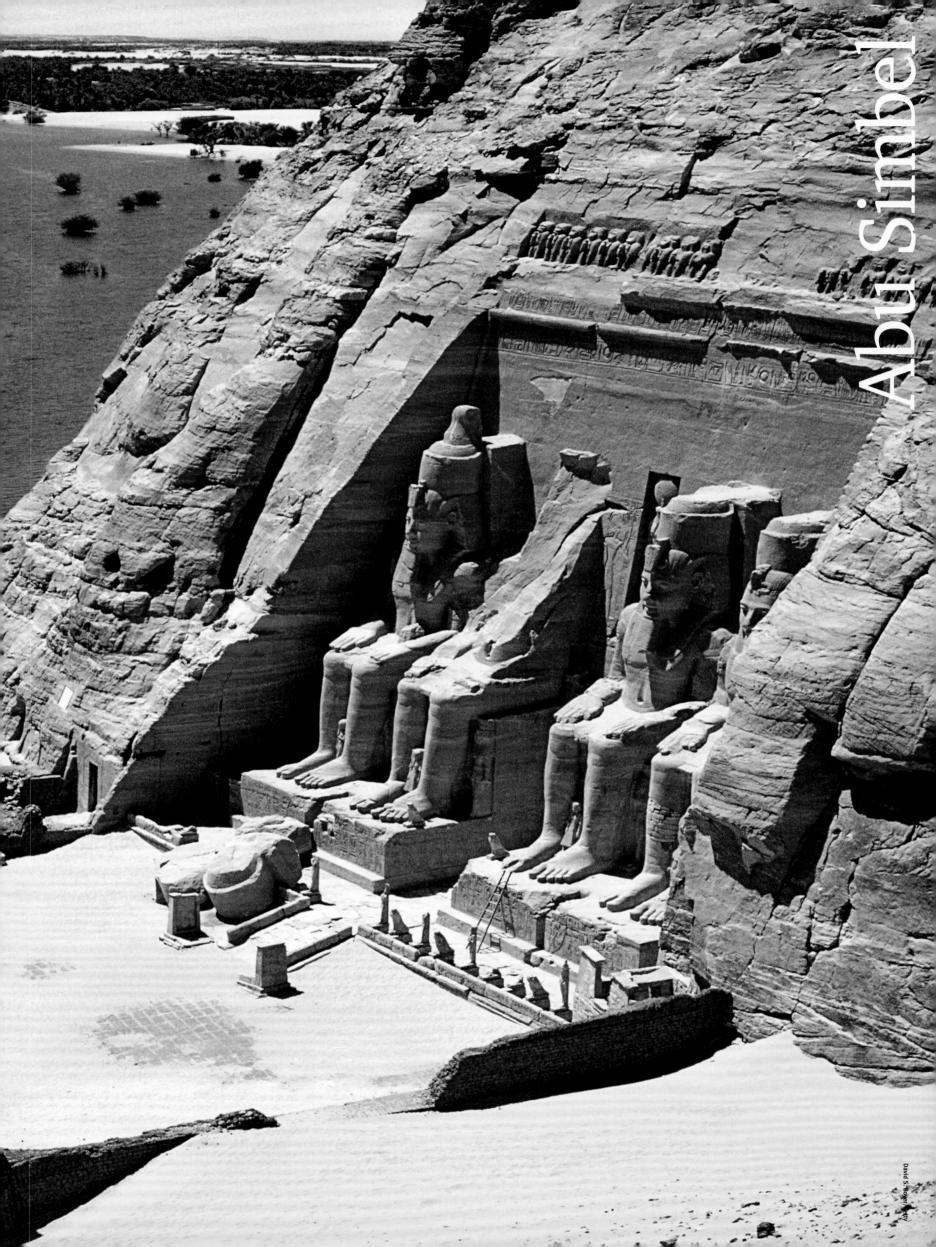

Iguaçu Falls

ore than twice as wide as Niagara, these horseshoeshaped falls make their magic on the border of Argentina and Brazil. During the rainy season, from November to March, 450,000 cubic feet of water per second crashes down with a roar that is audible for miles. Best of all, protruding ledges create an unending series of rainbows.

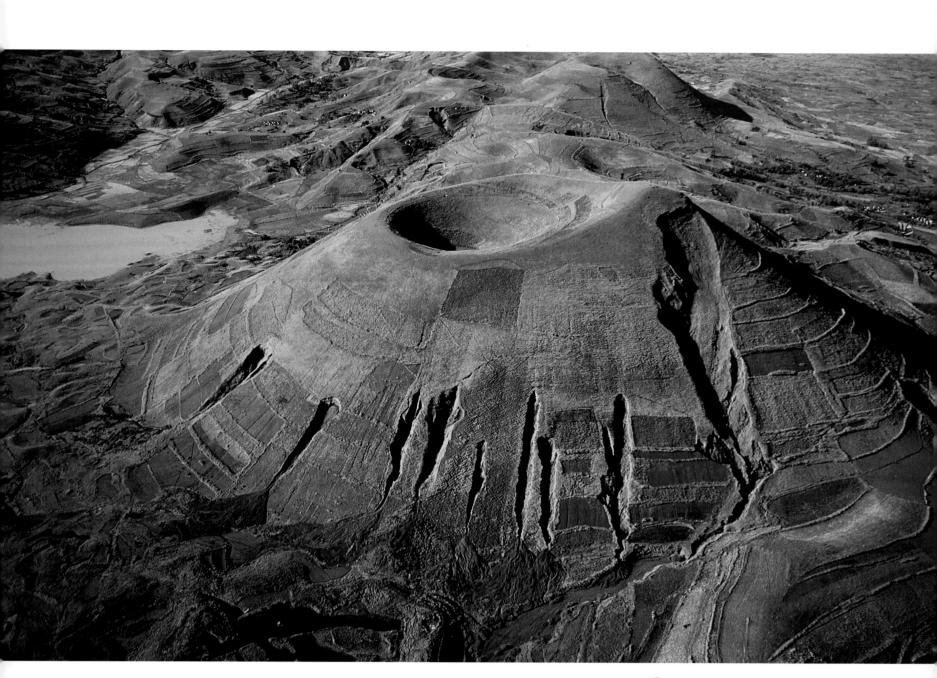

Madagascar

This island nation separated from Africa 165 million years ago, and today, despite economic and political challenges, it is without doubt one of nature's most bountiful treasure chests. Madagascar's isolation has led to its many remarkable inhabitants, such as lemurs, fossas, aye-ayes and tenrecs, which are even more interesting and strange than their singular names.

Amsterdam

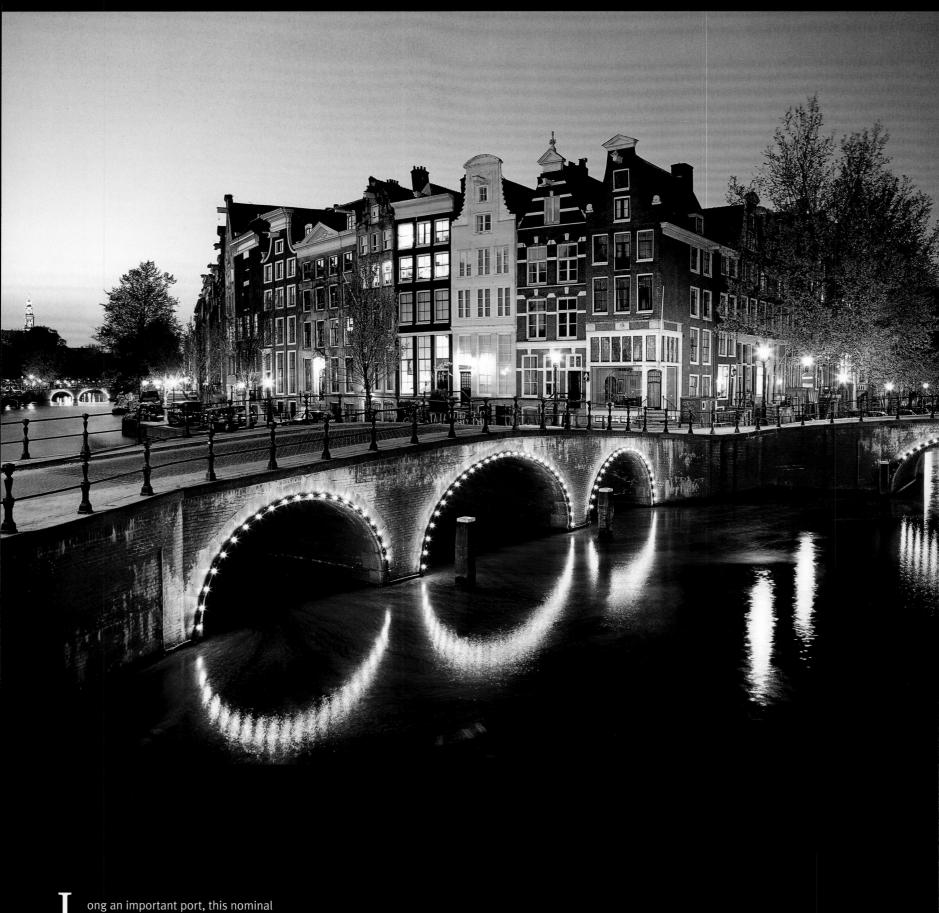

capital of the Netherlands is increasingly using its central locale within the EU to attract

A tiny nation bordering Mexico, Guatemala and the Caribbean, this was once the center of the Mayan civilization. Despite its size there is a tremendous variety of flora and fauna, and some of the friendliest people one could ever meet. There are rainforest and savanna, atolls and estuaries, but the cardinal calling card for Belize is its extravagant barrier reef, the longest in the Western Hemisphere.

Belize

Stonehenge

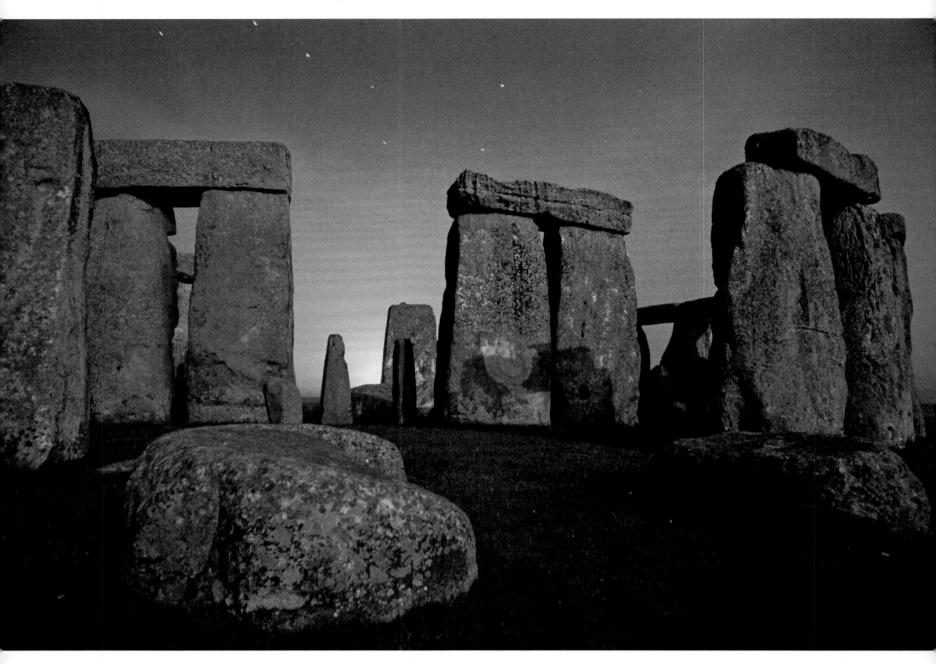

These entirely mysterious constructs on the Salisbury Plain in southern England have been studied by people from every aspect of society, and still the enigma remains. Who? Why? What? When? Stonehenge was no silly prank, it was a completely serious endeavor that suggests some understanding of our world that we no longer grasp. Stonehenge is magnetic.

Hong Kong

Busy, busy, busy. By day Hong Kong thrums with commerce, happy in its role as a center of finance and international trade, and a haven for dedicated shoppers. At night the energy level only goes up as folks indulge with gusto in the sundry forms of entertainment and the fabulous restaurants. Visitors will also be well advised to make occasional use of the city's serene parks.

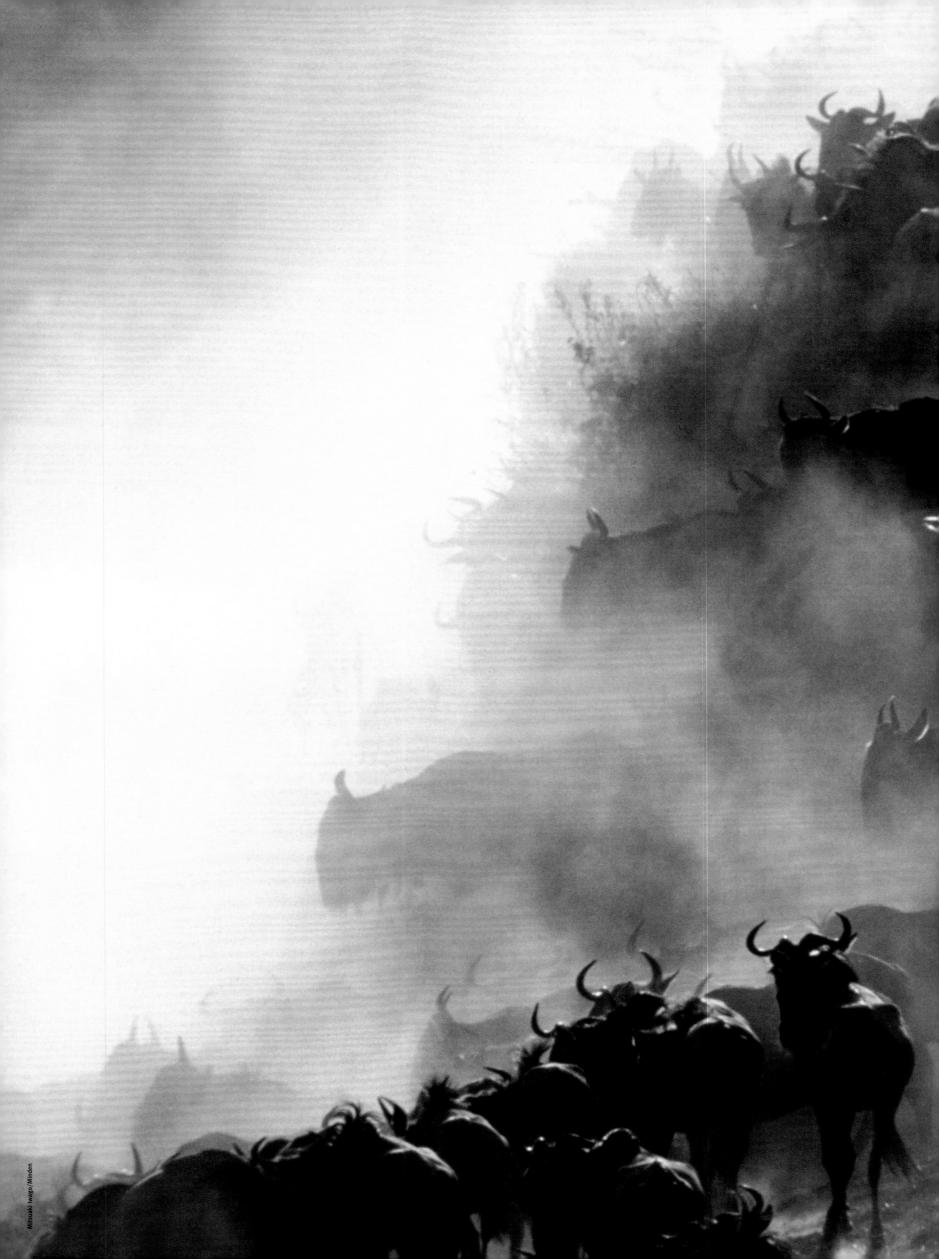

Millions of large animals dwell here in northern Tanzania, including vast numbers of wildebeest, zebra and gazelle. They assemble each year in the last of Africa's mass migrations, an eye-goggling, mindboggling flux of wild land mammals making their dazzling way to and from the savanna and the plains.

EGiant's Causeway

il the interior

On the edge of the Antrim plateau in Northern Ireland there is a strange and dramatic collection of 40,000 black basalt columns, mainly irregular hexagons, rising up from the sea as high as 40 feet. Although this "remnant of chaos," as Thackeray called it, was created by volcanic activity, legend has it that it was fashioned by a race of giants who strode from here through the waters to Scotland.

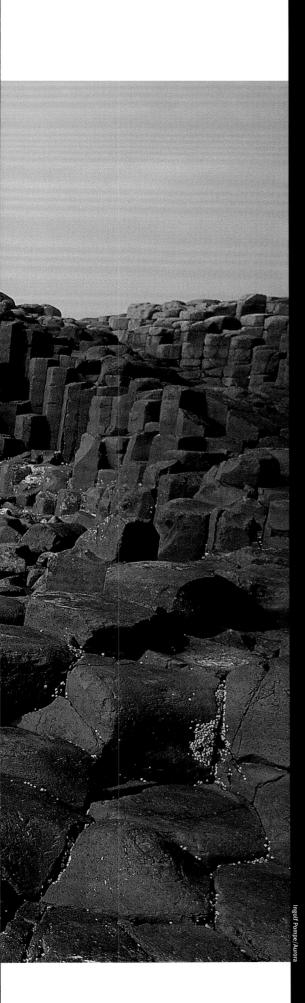

Yes, New Zealand does have nearly a dozen sheep for every person, but there is much more here than fresh lamb. A thousand miles southeast of Australia, across the Tasman Sea, the land is made up of two large islands, called North and South, and many smaller isles. Cities like Auckland are increasingly cosmopolitan, but the nation's isolation gives it a rugged, picturesque quirkiness unlike any other.

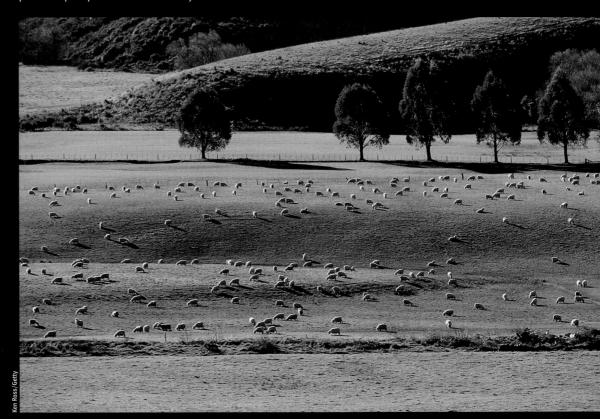

New Zealand

Istanbul

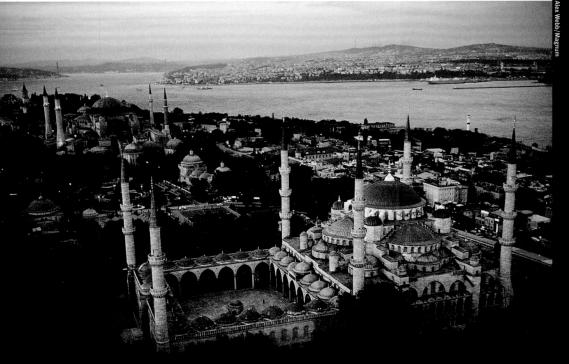

Founded as Byzantium, then known as Constantinople, Istanbul resides in both Europe and Asia, with the result that its culture is endlessly multihued. Located on the Bosporus Strait, with a natural harbor known as the Golden Horn, the city was long considered the capital of the civilized world. There remains ample evidence of this, perhaps foremost: Hagia Sophia, a cathedral that is the paragon of the Middle Ages.

> This highest of all the Alps takes root in France, Italy and Switzerland. Essaying any portion of the hiking circuit will quickly repay the effort. Mont Blanc, itself a sight to behold, is surrounded by a connucopia of architecture, culture, cuisine and to be sure, landscape studded with glaciers, pastures and waterfalls.

1 the

Mont Blanc

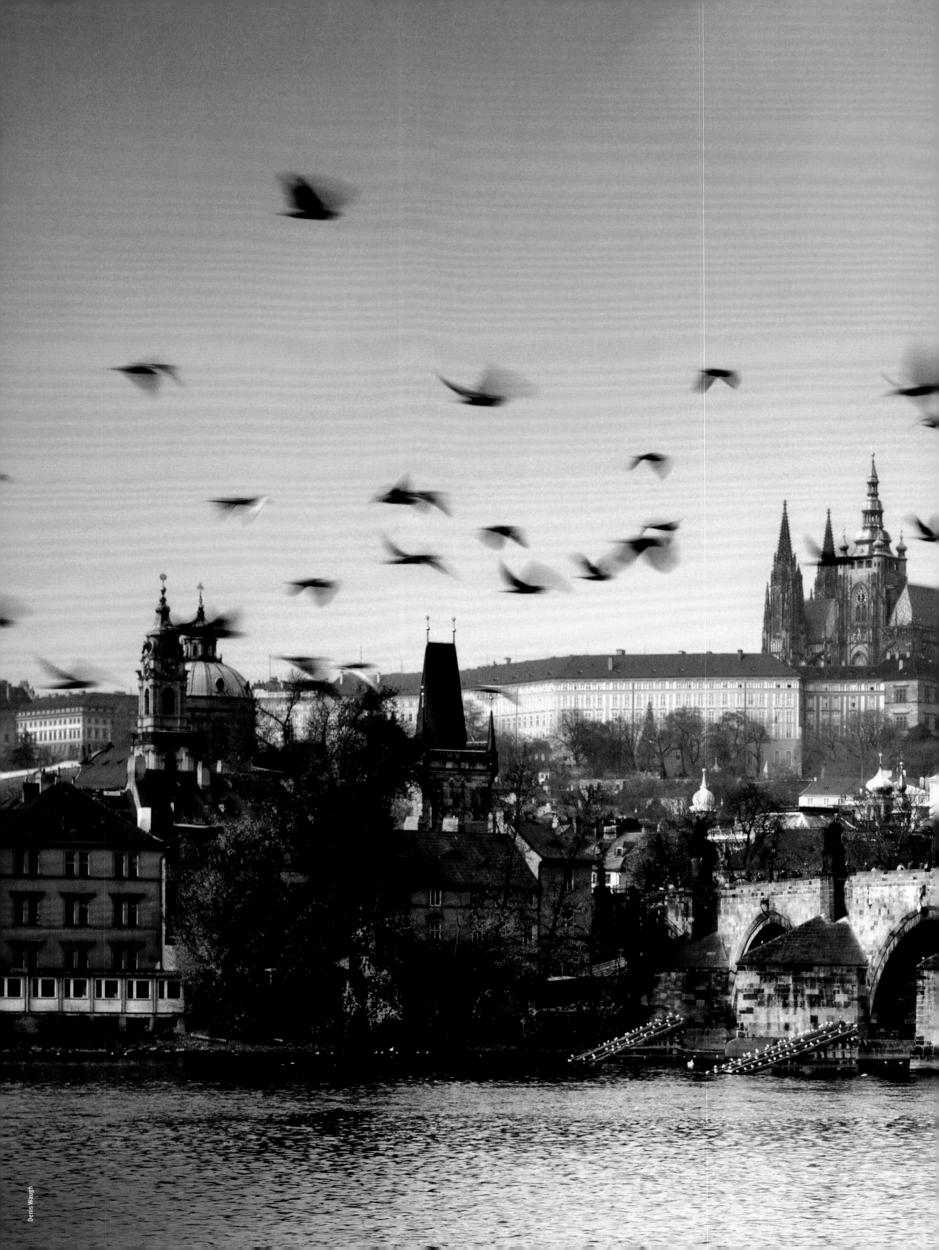

Prague

This capital of the Czech Republic has architecture from the Romanesque and the Baroque—it is known as "The City of a Hundred Spires"—along with gardens, ancient bridges, cobblestone streets and narrow lanes dotted with little pubs (Czech beer is first-rate). But at the same time there exists in Prague a contemporary atmosphere, bustling with the arts. After all, this is a land that chose a playwright, Vaclav Havel, for a president.

.

E

Barcelona

I ong known for its sense of individuality, Barcelona is a center of both commerce and art. It is a city of deep, flashing colors, with a tangible excitement that resonates from forested hills to one of Europe's busiest ports, nestled for centuries on the Mediterranean. Still, it is only in recent times that Barcelona has become a destination point, and that irresistibility only grows stronger.

ALIN

Great Barrier Reef

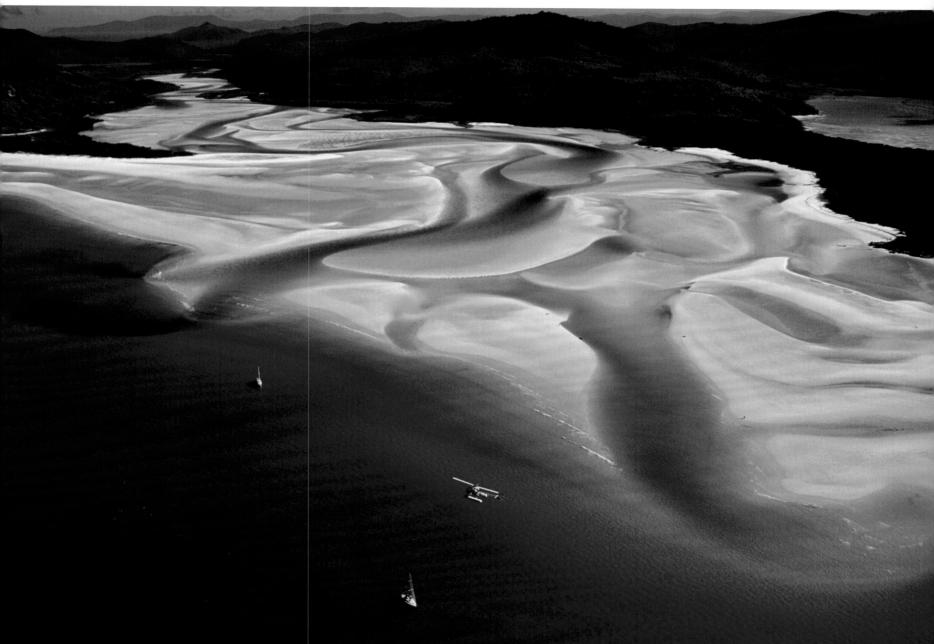

Set off the northeast coast of Australia is an interconnecting series of some 3,000 coral reefs that is about half the size of Texas and one of the Natural Wonders of the World. The Great Barrier Reef supports more than 1,500 kinds of fish, 4,000 different mollusks and 400 species of coral, and within its confines one can explore fabulous beaches, pristine rainforests and dozens of shipwrecks.

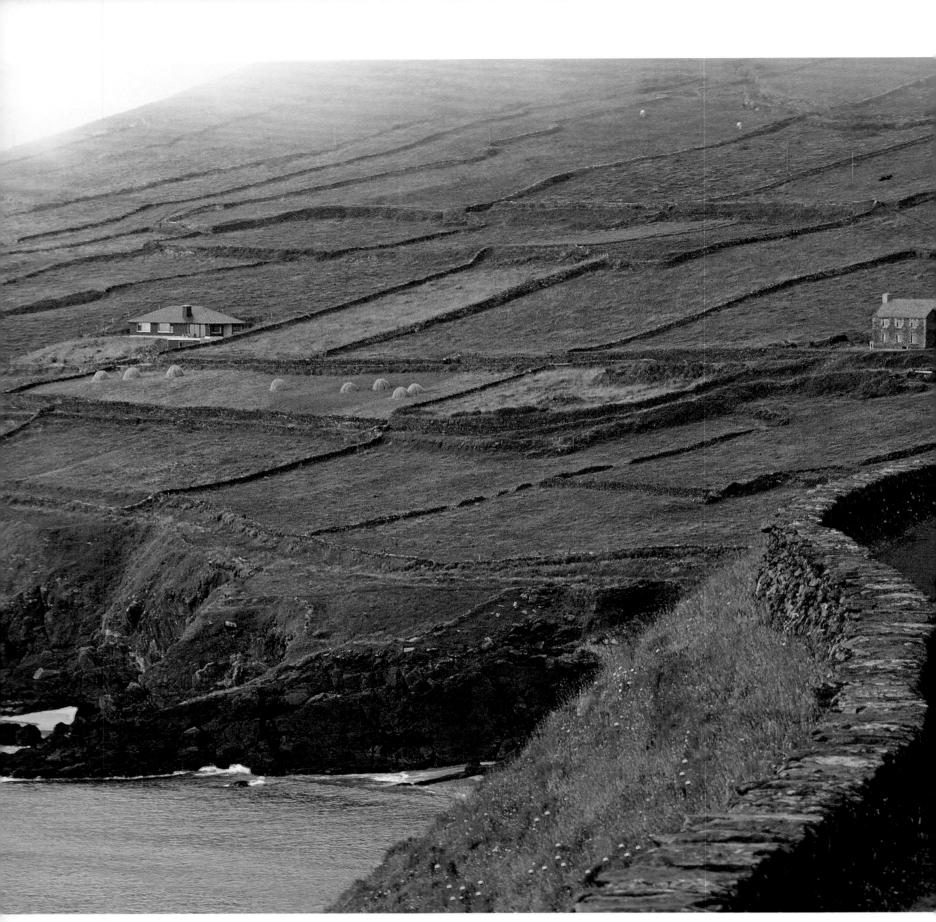

EDingle Peninsula

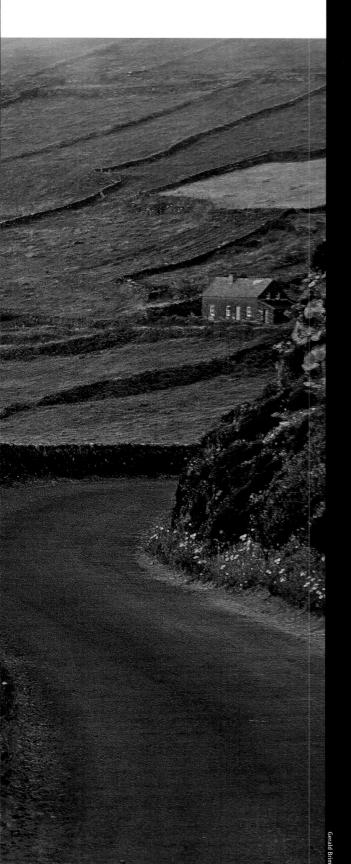

Reaching 30 miles into the Atlantic from the southwest coast, this piece of Ireland contains evidence from the Stone, Bronze and Iron ages, along with monastic sites, quaint churches and lyrical hamlets. The scenery is all green and stone, ranging from peaks above 2,000 feet to the hills and formidable cliffs of the west. You may recall seeing this splendid land in such films as *Ryan's Daughter* and *Far and Away*. his Belgian city reminds one of an exquisite miniature. One can't help feeling that the whole town—tiny streets, gabled houses, scores of bridges—has been lifted intact from the Middle Ages, with nary a stone out of place. Given its delicacy, it is appropriate that Bruges has long been synonymous with the making of fine lace, a popular souvenir.

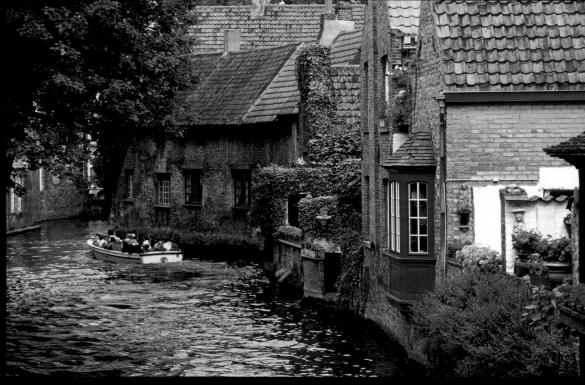

Bruges

Located in the southern Patagonia region of Chile, this 600,000-acre park is an unspoiled wonderland. Three mountains dominate the profile, and permit flora ranging from grassland to diminishing forests that suggest a Bonsai garden. There are glaciers, waterfalls and lagoons, with waters varying from blue to green. Fauna include foxes, condors, rheas (ostrichlike birds) and guanacos, which are related to llamas.

Torres del Paine

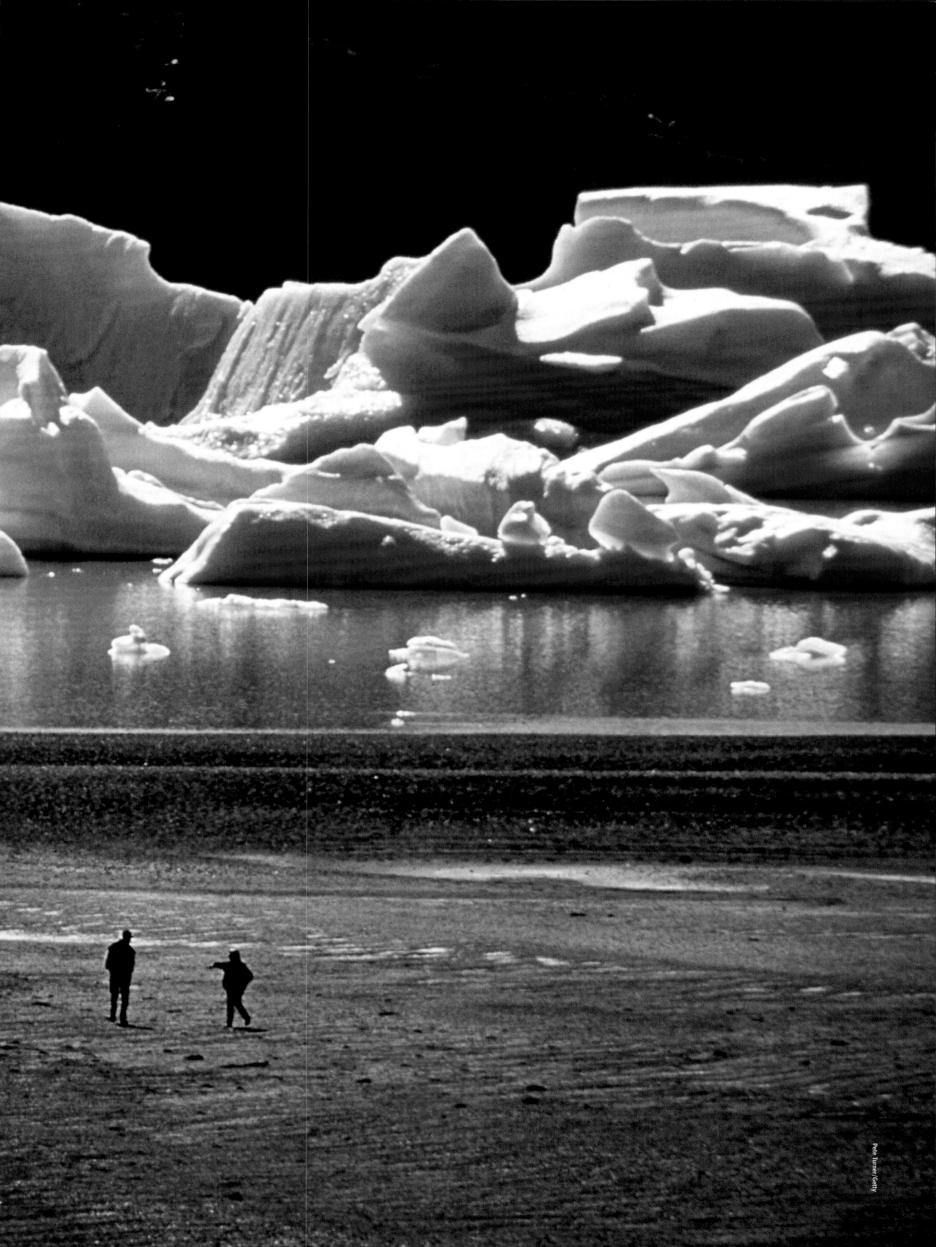

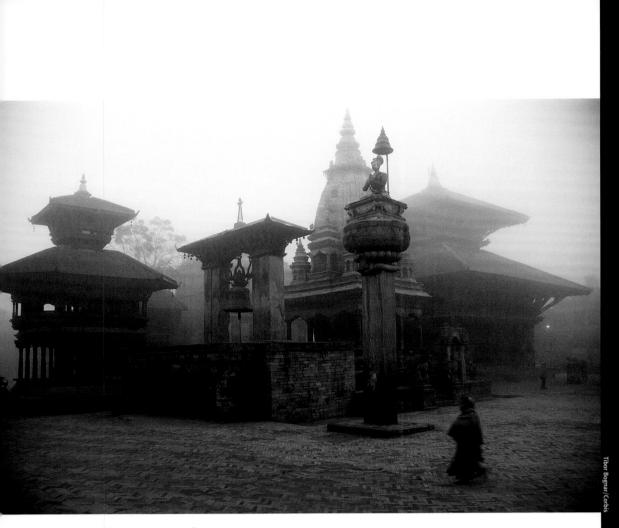

Bhaktapur

Founded circa 865 A.D., this town in central Nepal mesmerizes visitors with its profusion of monuments—typically terra-cotta artworks with ornate struts, windows and doors topped by gilded roofs and pinnacles. There are three majestic squares, led by Durbar, the site of the well-preserved Palace of 55 Windows, with its carved windows that become still more intricate as you climb to higher balconies.

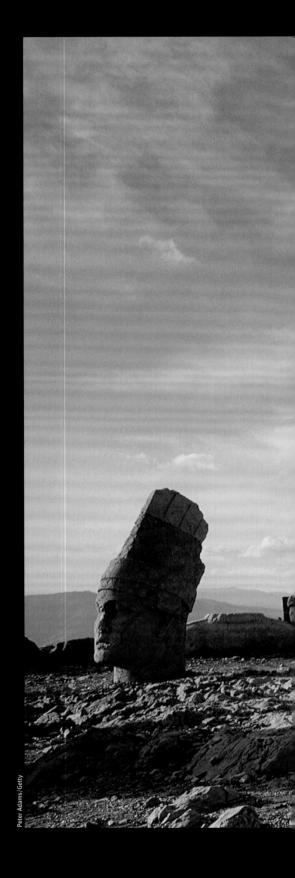

Mausoleum of Antiochus

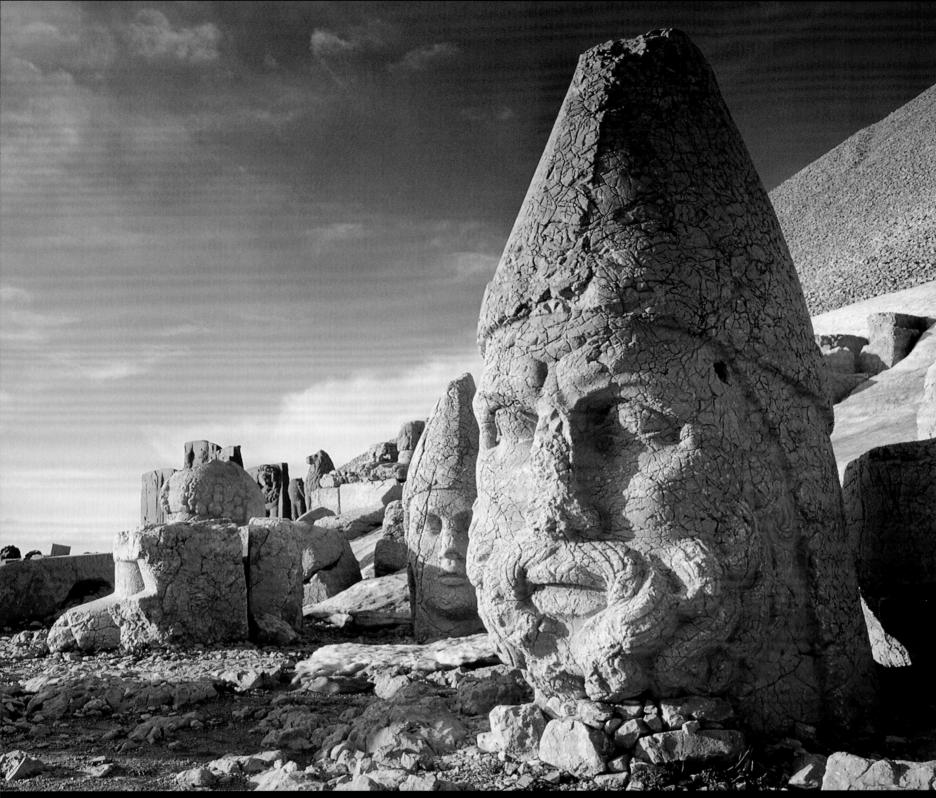

n what is today southeastern Turkey, there once was a region known as Commagene. During the 1st century B.C., its king, Antiochus I, elevated Commagene to its zenith—and thereby proceeded to order a mausoleum in his own honor on the peak of Mount Nemrut. The thoroughly impressive complex includes huge busts of both Western and Eastern divinities, a most unusual merging. Perhaps it should first be noted that this body of water, famed through its biblical associations, is actually a lake, through which the Jordan River flows from north to south. Beaches rich with avian life circumscribe the sea, itself home to a variety of fish. Not far from its shores, bananas and dates thrive. Thermal springs have led to modern baths; one at Tiberias is among Israel's top tourist resorts.

Kyoto

For more than a thousand years it was the capital city of Japan, and Kyoto today is the center of Japanese culture and Buddhism. Because of these historic qualities, the city was spared the fate of most other Japanese cities during World War II, and there remains standing a great deal of the old wooden architecture. Kyoto abounds with treats for the eye and the soul.

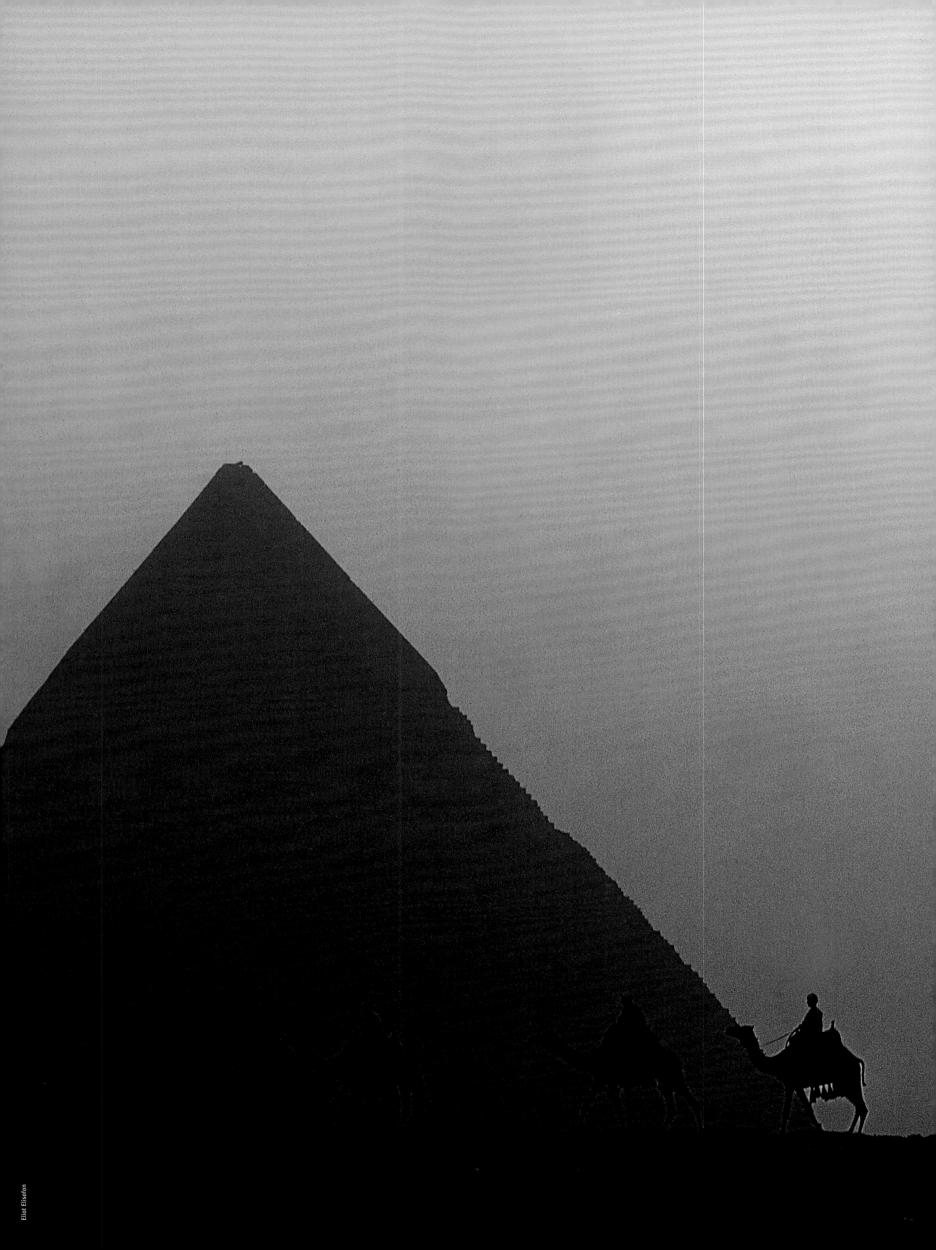

EGreat Pyramid

A cross the Nile from Cairo, holding forth as it has for 4,500 years, is the Great Pyramid of Khufu, the sole survivor of the Seven Wonders of the Ancient World. This was the highest building on earth for more than 43 centuries, a marvel of construction that imparts a serene sense of timelessness to any viewer.

Tallinn

1

IIII

4

1

-11

.

ii li

ā

111

ÍI

II II

-

11

1 1 1 0

=

The capital of Estonia, Tallinn sits on a bay in the Gulf of Finland. A settlement there was begun more than 2,000 years ago, but most of the interest today derives from the fairy-tale feeling fostered by its undeniably medieval atmosphere: It is a delight to stroll the cobblestone streets laid inside the old city walls, with all about red-tiled roofs and pewter-colored steeples.

Nowhere else combines such intense vitality with an urban setting of such preposterous magnificence. Rio has its problems—poverty is ubiquitous—but its spirit is sustained by such as the thrilling Sugar Loaf Mountain, overlooking the grand harbor; the giant statue on Corcovado of Christ the Redeemer; and the epic beaches Copacabana and Ipanema. Add in the music, food and soccer, and there is nothing to compare with Rio.

Rio de Janeiro

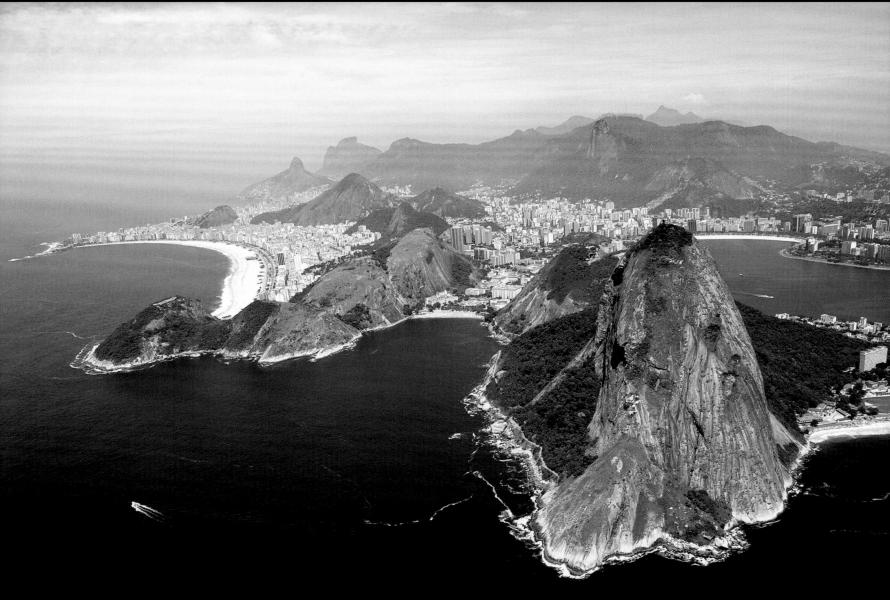

Petra

A few hours south of Amman, Jordan, one passes through a long, narrow gorge and suddenly enters into the ruins of an ancient city "designed to strike wonder" in all who behold it. Carved out of rose-red sandstone cliffs are some 800 temples, theaters and tombs. As if the exteriors weren't enough—and they are—the interiors of the tombs are often a tapestry of color due to natural variations in the sandstone.

Black Forest

The source of the Danube River, countless cuckoo clocks and enough fairy tales to fill a childhood, the Black Forest covers 2,320 square miles of southwest Germany. An utterly enchanting place, its natural spring waters were enjoyed two millennia ago by Roman soldiers, and today those seeking a boost to their spirits go to such spas as Baden-Baden and Wildbad. Majestic castles round out the magical feeling.

In the southern Chinese city of Guilin, there are more than 100,000 osmanthus trees, splendid with their fragrant white flowers. Belowground, there is also a marvelous system of large caves. However, what keeps the visitors coming in droves is the steep conical limestone hills, bearing names such as Lonely Eminence and Piled Festoon, that rise up from the Li River in a masterpiece of nature.

Guilin

37.5

Ç

Bokavango Delta

Where the Okavango River terminates in Botswana it brushes against the sands of the Kalahari Desert, creating a dramatic amalgam of crystal-clear waters, swampland and savanna. This is the largest inland delta on the planet, one of Africa's dwindling unfettered wilderness areas. From dugout canoes one can see cheetah, zebra, crocodile, hippo, stork and other superb wild creatures.

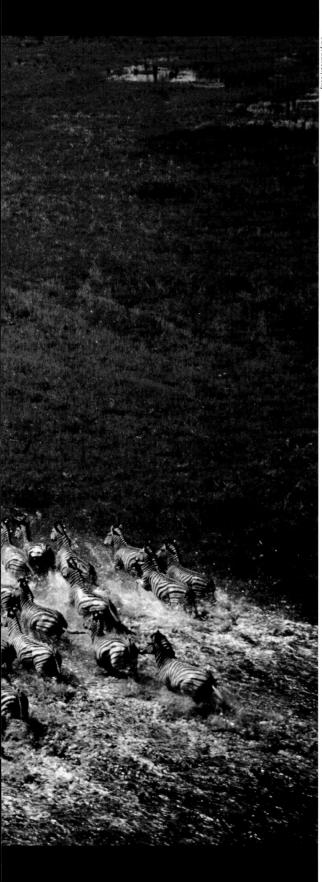

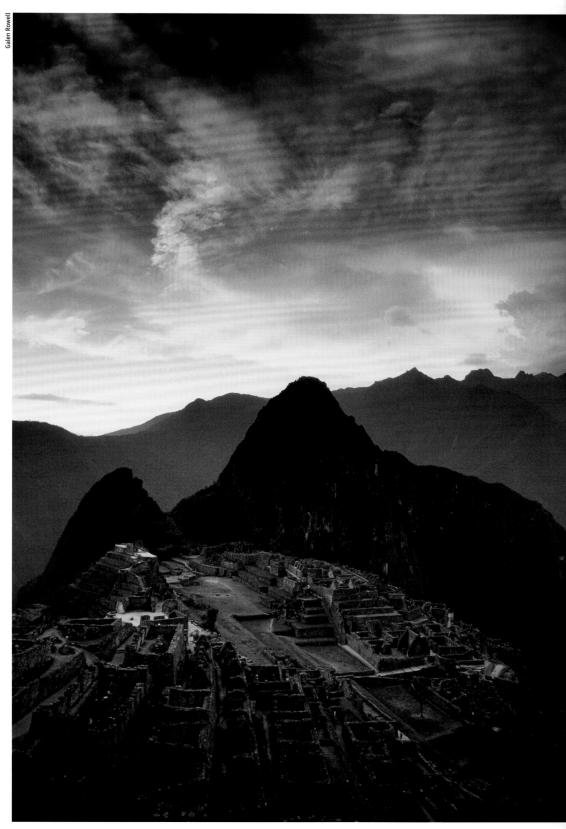

Machu Picchu

Set high in the Andes between two sharp peaks is a pre-Columbian fortress city that is an Incan mystery for the ages. Created in the 15th century as a royal estate, it was unknown to the outside world until an American discovered it in 1911. The isolation was indeed a boon in preserving the exquisitely executed granite masonry.

he ruins of this Roman amphitheater, which was begun in 72 A.D. on the site of a villa that once belonged to Nero, are of such perfection that one can scarcely imagine what it was like in its totality. There were 80 entrances: 76 for ticket-holders, two for gladiators, and two for the emperor. The bizarre spectacles that took place within are long gone, but the awesome aura of the Colosseum is forever.

Ecolosseum

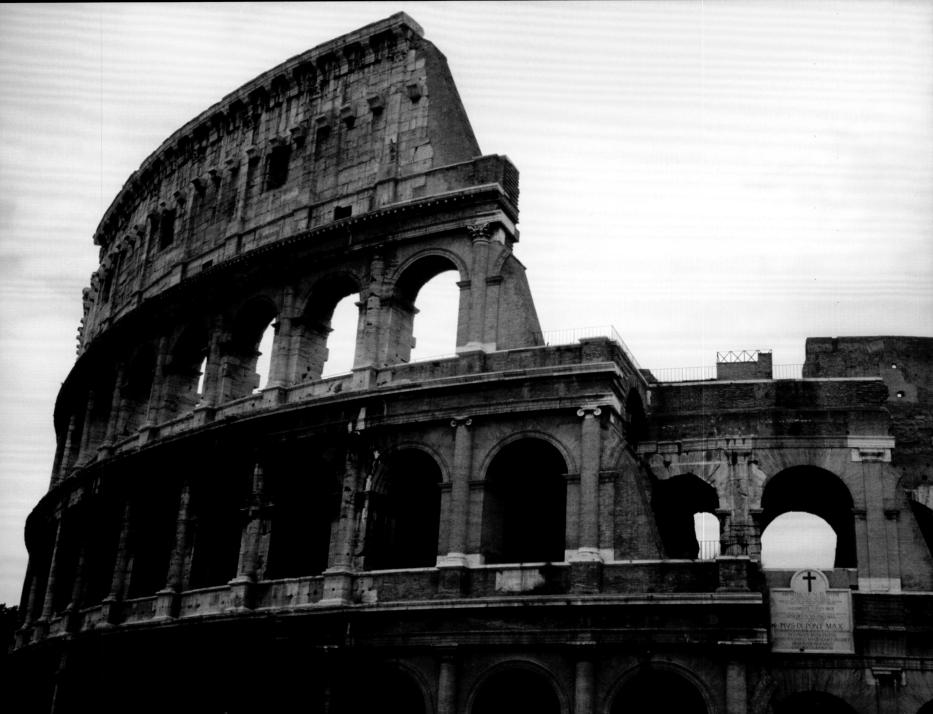

Barbados

ocated at the eastern tip of the West Indies, Barbados has long attracted those who enjoy white and pinkish beaches that stretch along light blue waters in a superb climate. The country became independent in 1966, but its Britishness is still evident in such pursuits as cricket. Mix in succulent food, rolling hills and a delightful natural cave, and the isle's popularity is no surprise.

St.

各座

Iceland

This island the size of Kentucky is situated within a triangle formed by Greenland, Norway and the U.K., but for first-time visitors, it may as well be in another solar system. The "Land of Fire and Ice" has geysers and glaciers, lake-filled craters and lava deserts, and spas like the Blue Lagoon, a geothermal bath rife with minerals. And the capital city of Reykjavik has become a premier getaway for nightlifers.

The liter of the l

Mannes States

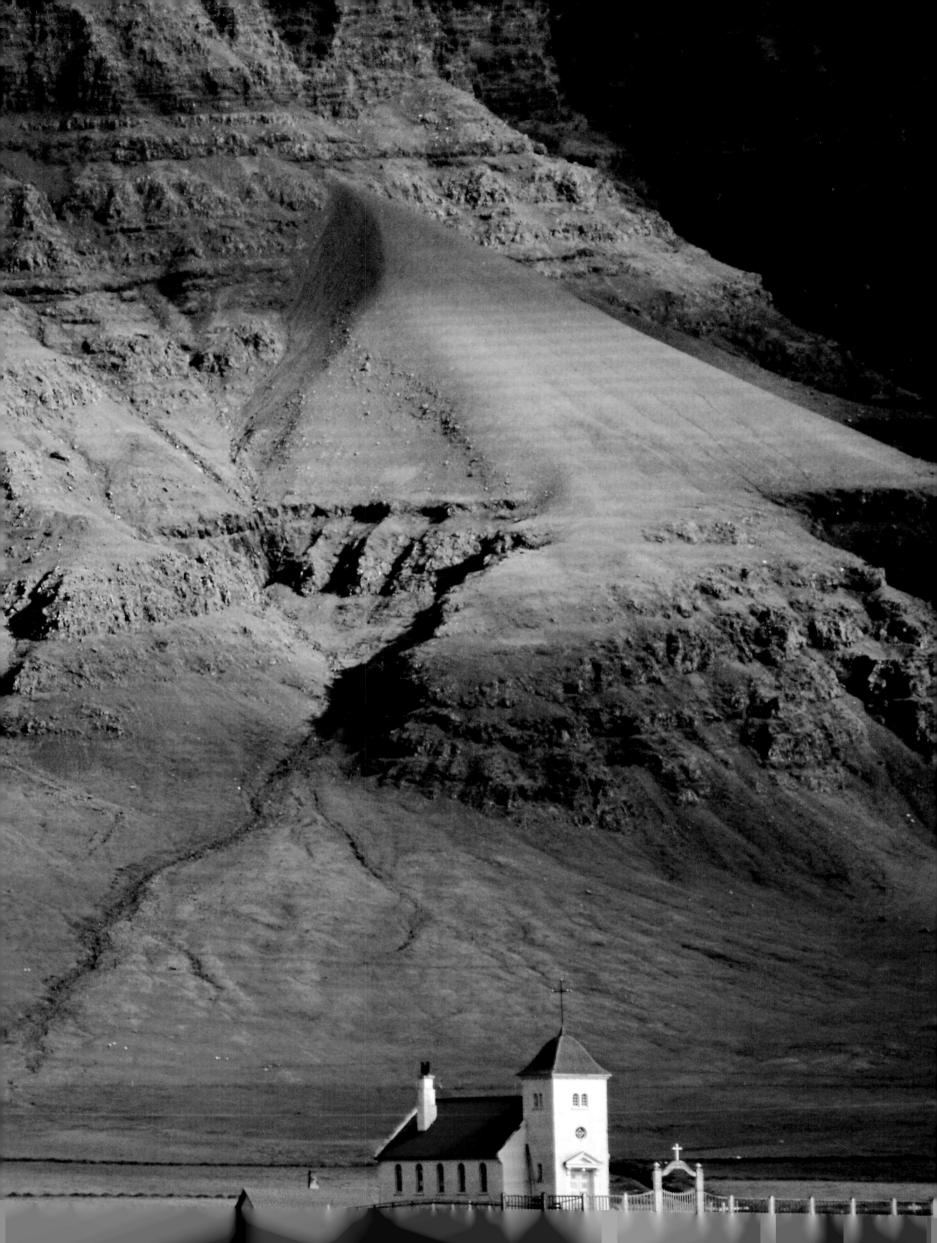

Seychelles

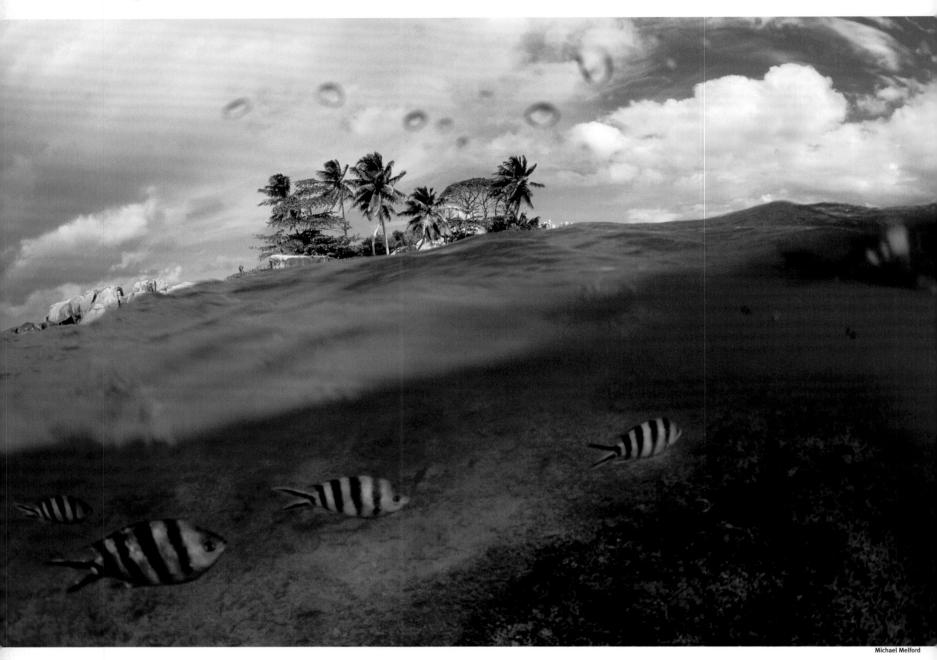

Originally settled by the French, this nation of some 115 islands lies in the Indian Ocean 1,000 miles east of Kenya. The very pleasant climate of the Seychelles is home to forests, fishing, diving and outgoing natives. Anyone who longs for the feel of high hanging gardens adjoining powdery white-sand beaches with turquoise waters may want to seriously consider spending some time here.

Churchill

Taj Mahal

DANAAA

111

Sterroy

Itti

The dama

Twenty thousand workers were called upon in the 17th century to build this mausoleum for the Mogul empress Mumtaz Mahal, in Agra, in northern India. Made of white marble on a platform of red sandstone, the tomb is part of a complex of such divine harmony and fluidity that it stands as one of man's greatest achievements.

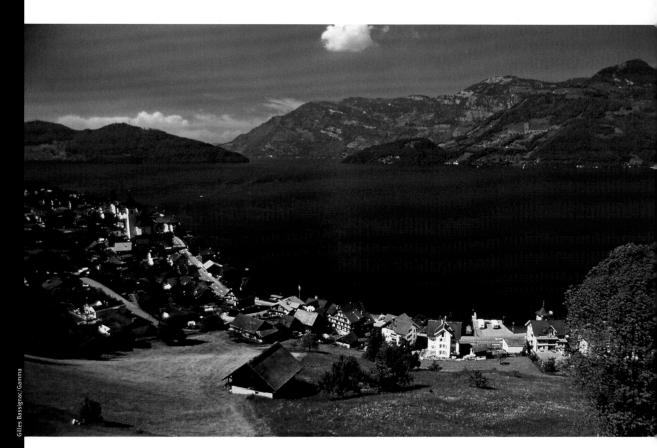

Lake Lucerne

Switzerland is justly famed for its pulchritudinous waters, but surely this is the fairest of all. Located in the heart of the country, Lake Lucerne is bounded on all sides by limestone mountains brimming with forests that often reach right down to the waters. Its irregular shape guarantees scenic diversity, set within an atmosphere suffused with the legends of William Tell.

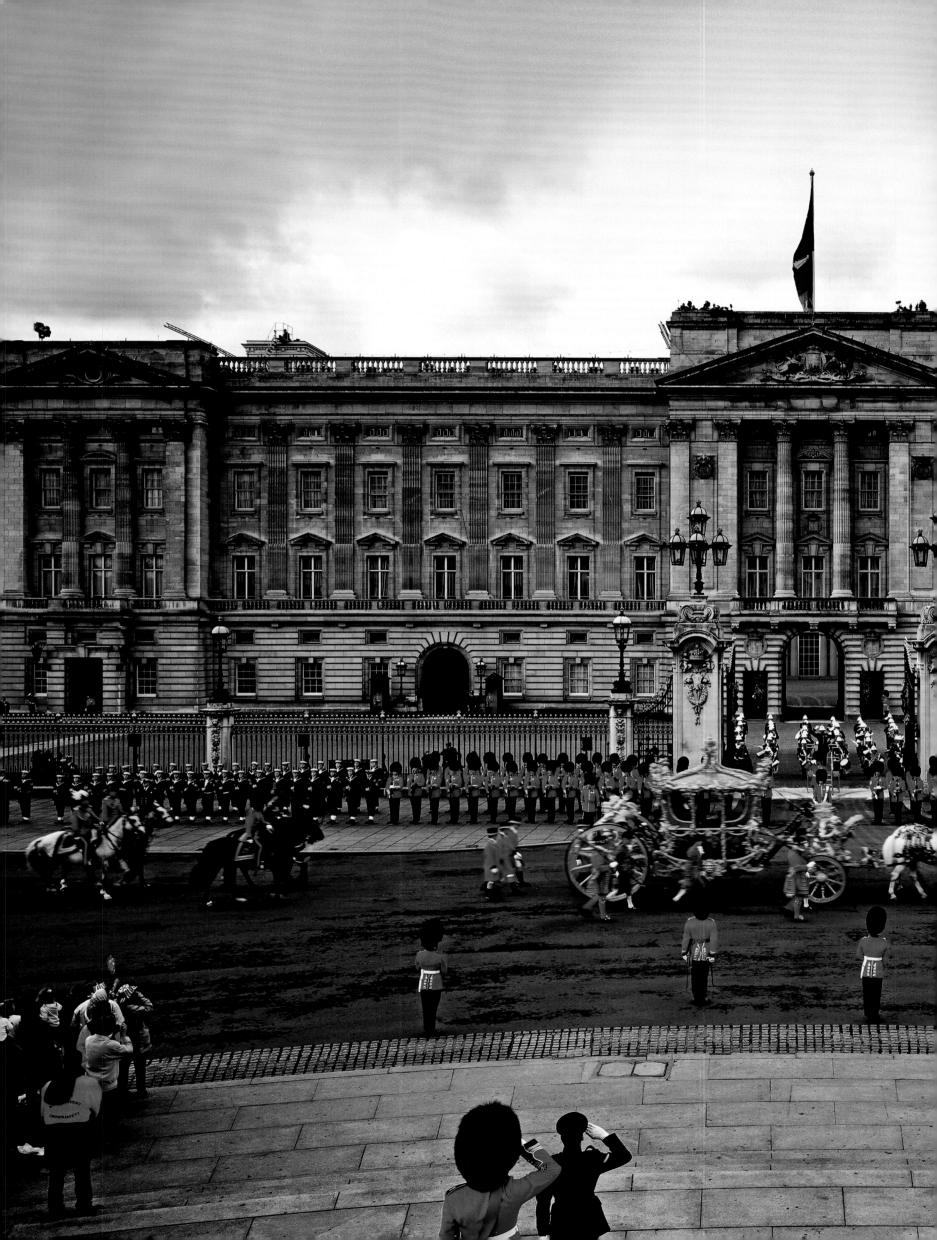

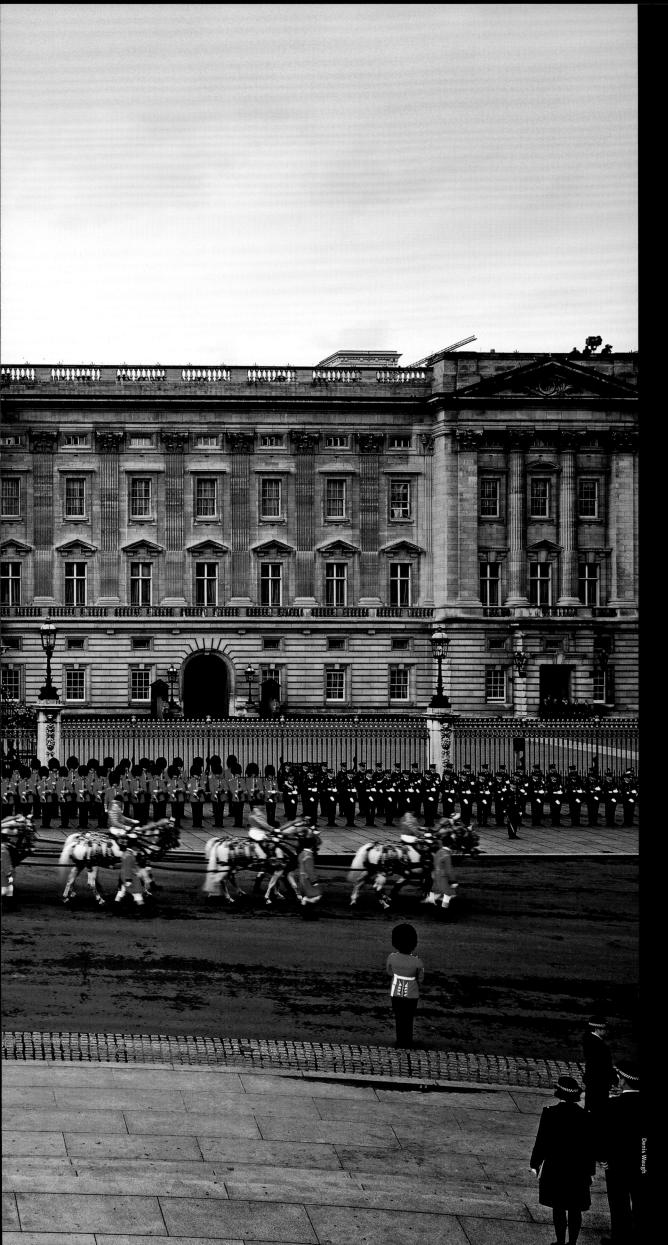

London

ne of the world's great cities, London has a plenitude of famed landmarks, like Big Ben, Westminster Abbey and Buckingham Palace (seen here), but it also has everything else one looks for in a premier urban environment. The architecture is varied, the parks are well placed, the culture is unsurpassed, and now even the food is superlative. London is ... well ... loverly.

Bermuda

I fyour idea of heaven is nude beaches by day and nonstop discos by night, steer clear of Bermuda. However, if trim gardens, pastel cottages, welcoming shops and oodles of pink sand beaches leading to Gulf Stream waters sound good, then this is just the ticket. About 650 miles off North Carolina, Bermuda is actually scores of islands and islets, the largest connected by causeways and bridges. The rest you'll have to reach by boat.

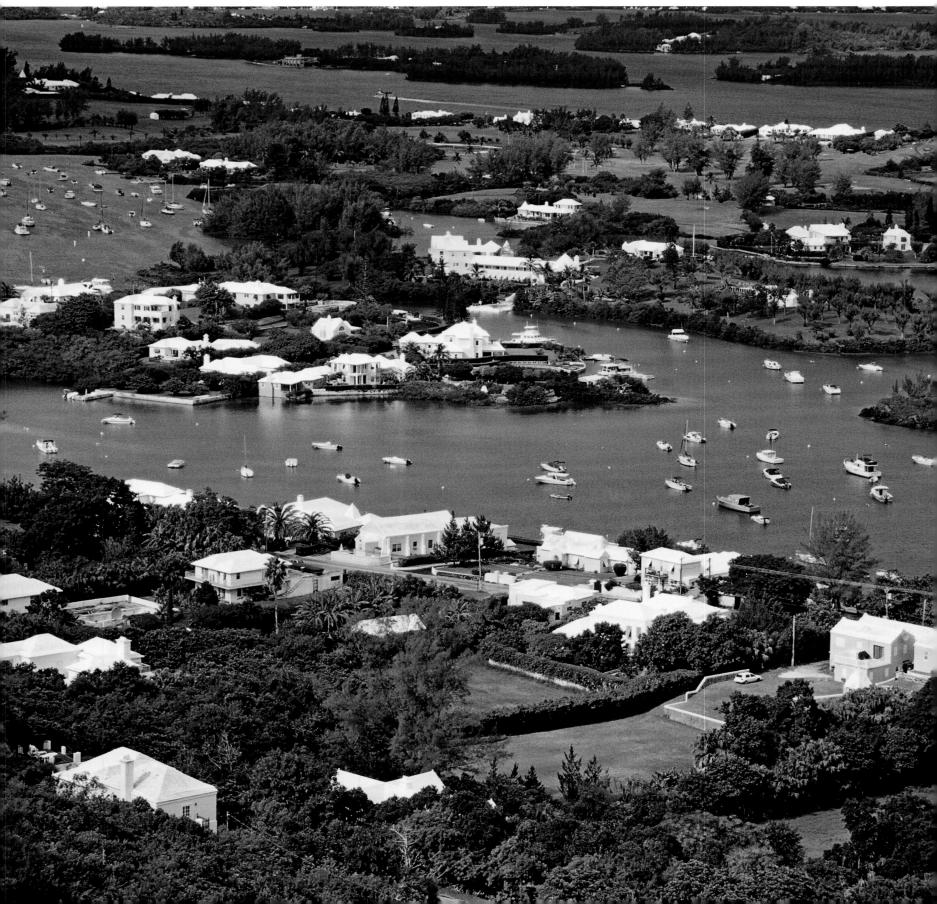

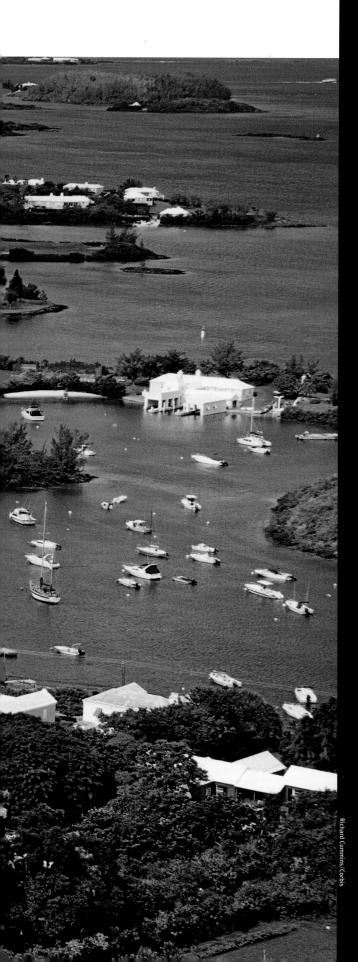

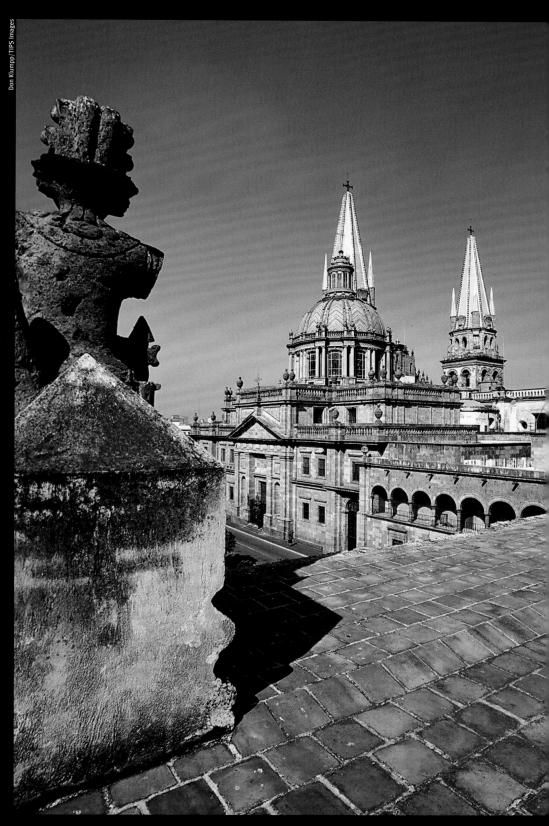

Guadalajara

K nown as both The Pearl of the West and The City of Roses, Guadalajara, in west-central Mexico, has all the amenities one would expect from a city of six million, yet it retains the intimacy of traditions that have survived for centuries. The many plazas have their own character, and the streets, filled with cathedrals, mansions and theaters, are lined with trees and plants. As a tangy fillip, the city is famed for its mariachi bands and tequila.

Potala Palace

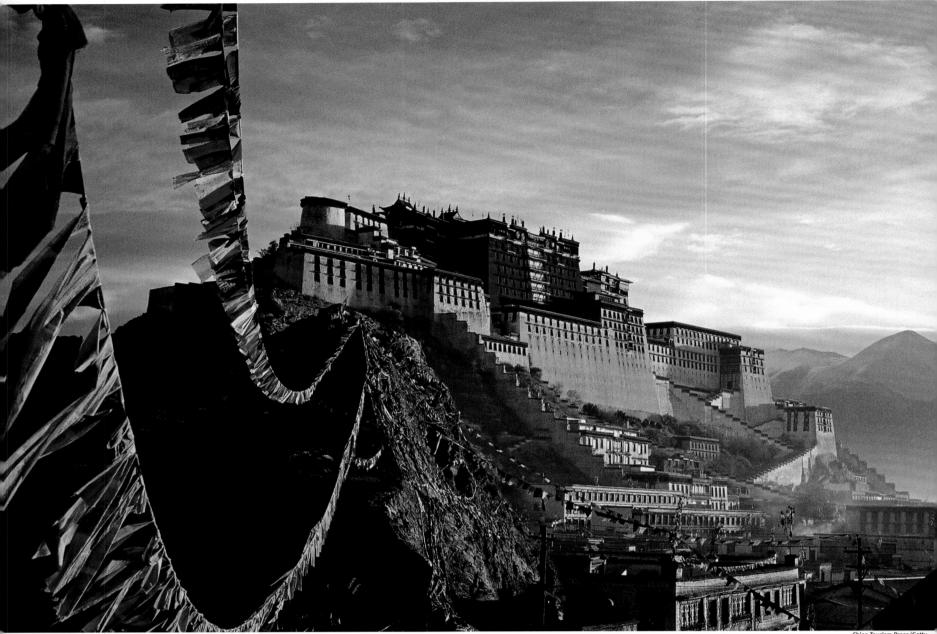

Set on a hill overlooking Tibet's Lhasa valley, Potala has been the winter palace of the Dalai Lama for centuries. Divided into the White Palace (secular) and the Red Palace (sacred), the complex includes more than a thousand rooms with exceptional murals, carved columns, and statues and decorations ablaze with gold, silver, pearls and other gems.

Tasmania

A triangular island lying off the southeast coast of Australia, Tasmania has a large, wondrous eucalyptus forest that counts among its denizens such colorful birds as parrots, honeyeaters and cockatoos. The isle's distinctive mammals include the tiger cat, wombat, platypus and the Tasmanian devil. Culture also plays an important role here, not least the very fine symphony orchestra. Yes, it is justly renowned for its unmistakable Opera House and important single-span arch bridge, but Sydney Harbor has much else to recommend it. Sailing in its aqua waters is a delight for residents and tourists alike, while S.H. National Park affords memorable views of islands, cliffs and beaches.

111111

Sydney Harbor

Haldives

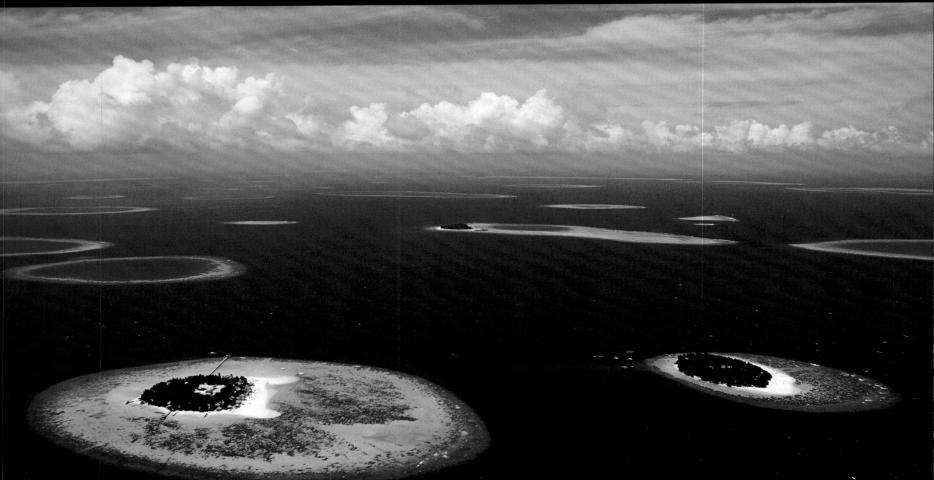

F ound in a national park in central Japan, Jigokudani translates as "Hell's Valley," perhaps an odd name for inclusion in this volume, but an eden for those who enjoy fantastic winter landscapes and animal events that border on the dreamlike. In the cold months, hundreds of Japanese macaques come down from the frigid forest to luxuriate in hot springs bubbling to the surface. The monkeys are quite accustomed to the sight of humans happily watching them being happy.

Dubrovnik

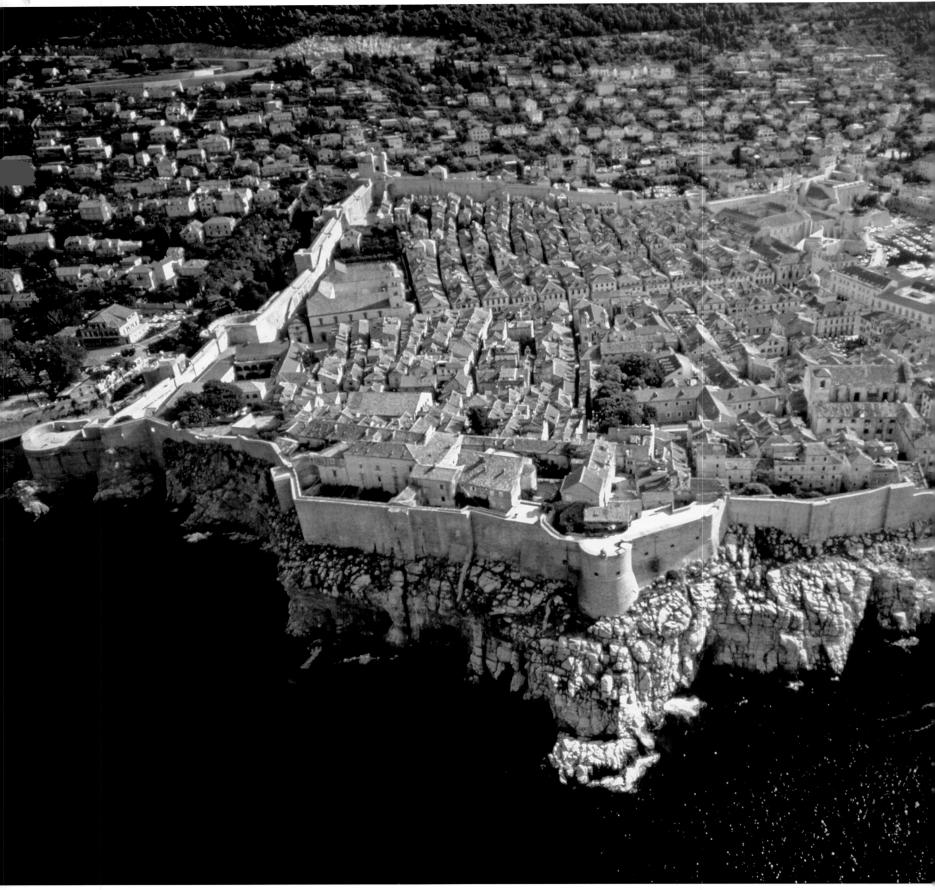

The Pearl of the Adriatic is in Croatia, in the area known as Dalmatia. Despite being hit by earthquake, fire, war and tidal wave, Dubrovnik is an exemplar of medieval urban planning. Sited on a promontory overlooking the sea, the city lies within fortifying walls, and is a paradigm of narrow, twisting, endlessly attractive streets holding gardened villas, monasteries and palaces.

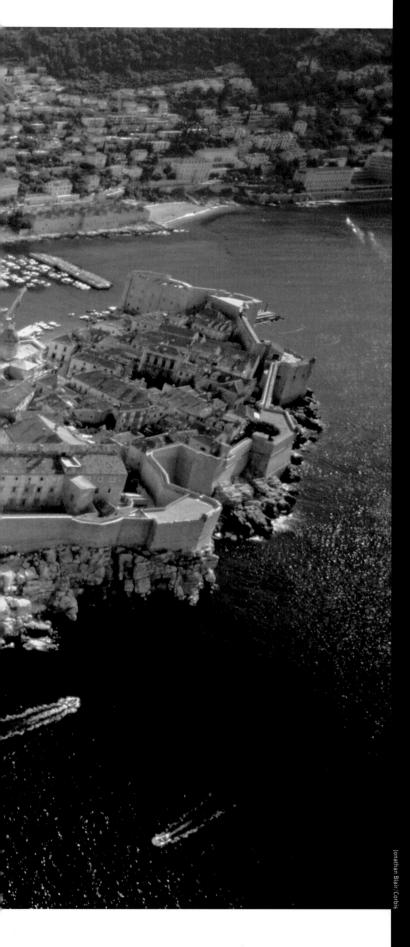

This capital city reaches from the Rio de la Plata to the pampas, Argentina's extensive, fertile plains. BA is rather unique for South America in that it is dominated not by the typical Spanish colonial feel but rather a strong European heritage and an architecture informed by high rises as much as older, ornate palatial mansions—in short, a very winning melange of cultures.

Buenos Aires

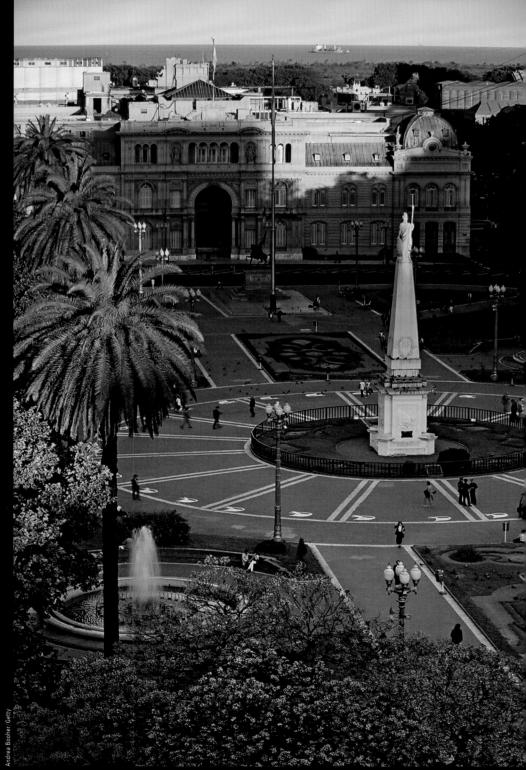

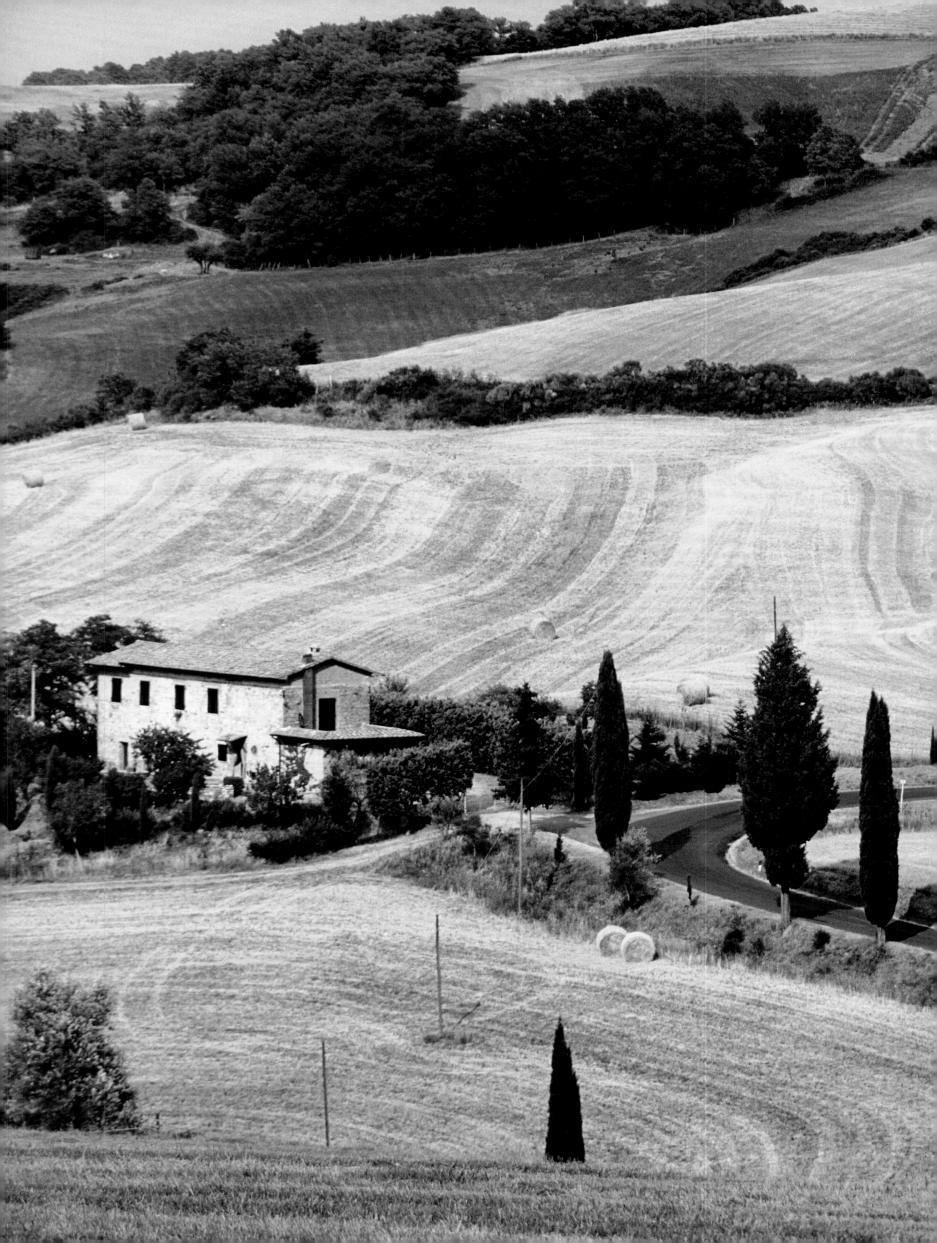

I t is fitting that this sublime region of central Italy played such an important part in the Renaissance, for it is nothing short of a masterpiece, with its snow-peaked mountains across its rolling hills and tilled fields, its unforgettable cypress trees, and finally, its romantic coastal towns on the Tyrrhenian Sea. Art, wine, food, castles, all of them nonpareil.

the state of the sum and a set

Isle of Wight

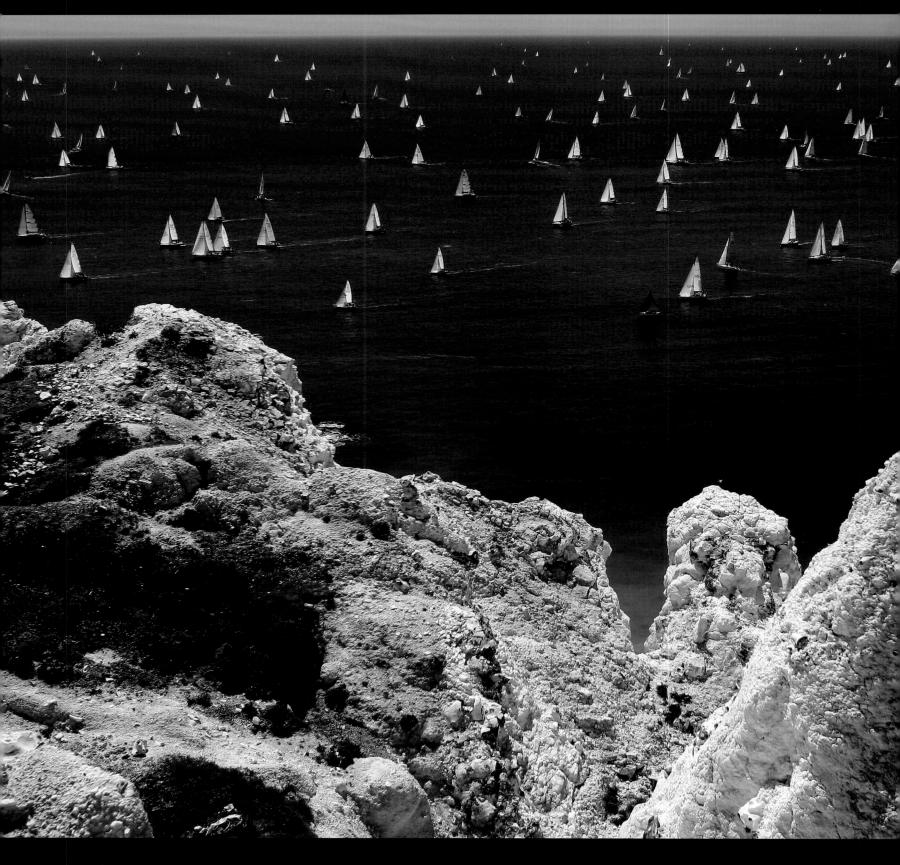

ying off the southern coast of England, in a turbulent part of the English Channel known as the Solent, this diamond-shaped island has long been a popular vacation destination. The landscape is unusually diverse—thus its nickname, England in Miniature—with soft cliffs and fetching coastlines accentuated by the Needles, three chalk pinnacles in the west that rise to 100 feet.

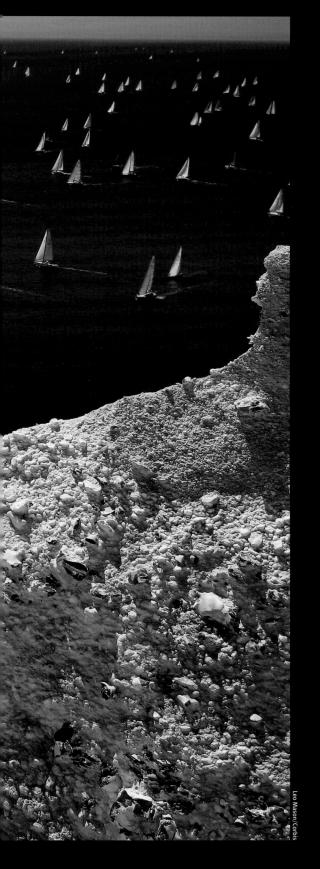

Monte Albán

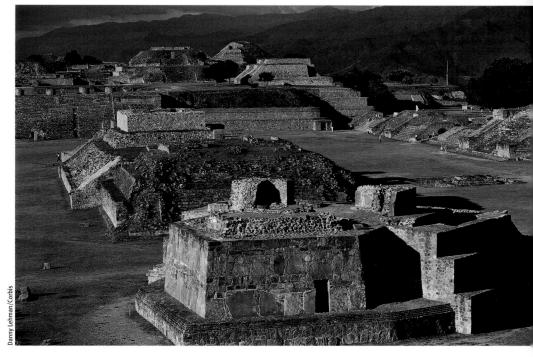

A flattened mountaintop some 5,000 feet above Mexico's Oaxaca Valley is the site for Monte Albán, the ruins of the nerve center of the ancient Zapotec culture. Construction began some 1,000 years ago and, over time, included temples, fabulous plazas, an observatory, underground passageways, a ball court, and the most intricate system of tombs extant in the Americas. The ceremonial center of the Mayan civilization, these ruins in Guatemala can exert a potent sense of spirituality with pyramids rising above the treetops, palaces, terraces and temples superbly crafted from limestone in the midst of dense jungle. The first village took root nearly 3,000 years ago and, over time, became a site engineered to measure up to the most important of rites, as well as a vital city of 100,000 people.

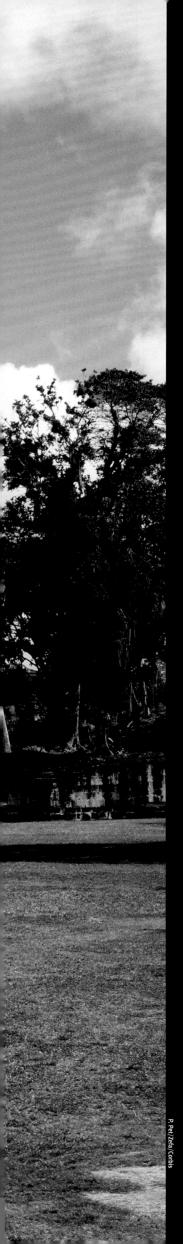

Paris

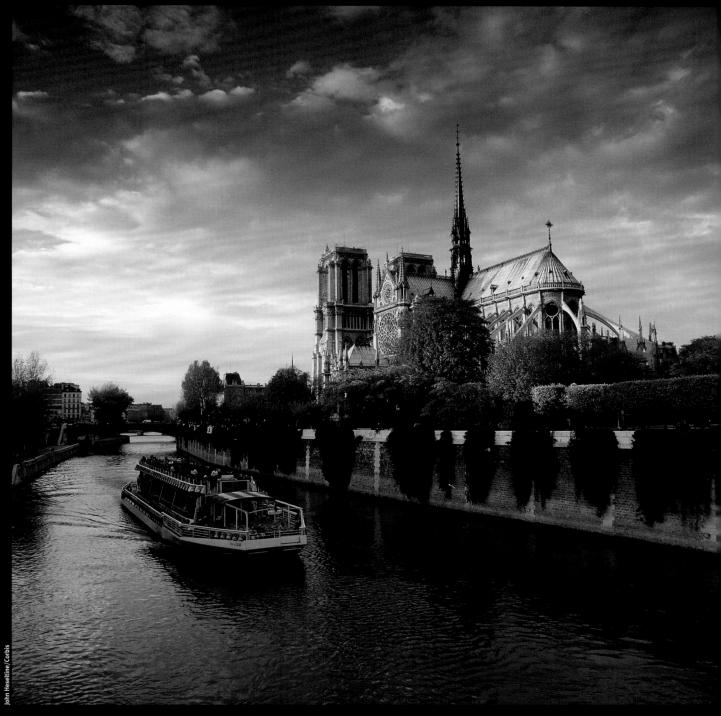

I fone were to choose a single city to represent Earth in an intergalactic competition of urban splendors, The City of Light would be a most worthy candidate. With the Seine providing a steady pulse, Paris has for two millennia been a center of cultural and economic activity, all carried out in an atmosphere of accomplished beauty and grandeur, colored through with indelible romance.

Copenhagen

H H H

HHHH

山山山

II

HHH

F

F

HINI IIIIII

i siitiseet

THE

ith 1.5 million people, this is Scandinavia's largest city, yet it is a blissfully calm place that is sophisticated but sane. The popular pleasure garden known as Tivoli has flowers, fireworks and fountains, while a life-size statue of Hans Christian Andersen's The Little Mermaid graces the harbor. And if you're peckish, think smorgasbord, think pastry.

ii ii

F

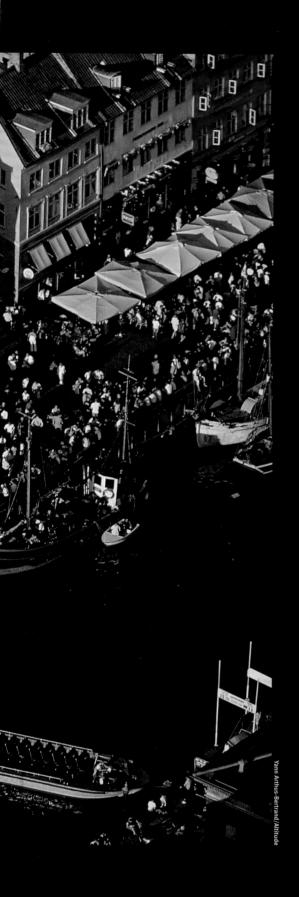

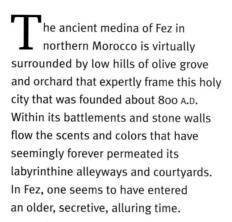

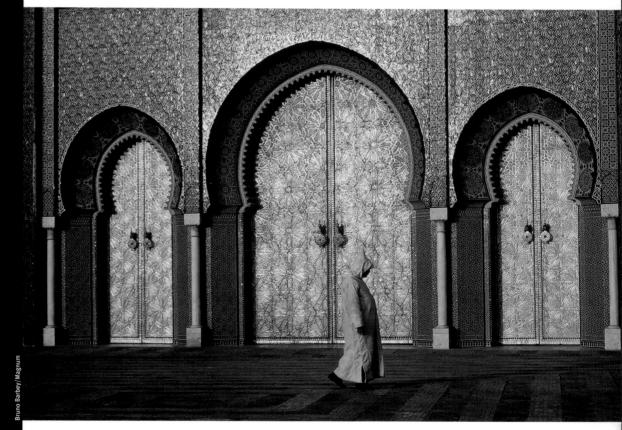

Fez

冒Lot

This agricultural region in southwestern France, which takes its name from the meandering Lot River, has long produced fine black truffles and walnuts, and is also a source of superior foie gras. The Lot fairly teems with rustically enchanting medieval villages built hard against rough-hewn cliffsides. At Pech Merle there is a cave with prehistoric wall paintings.

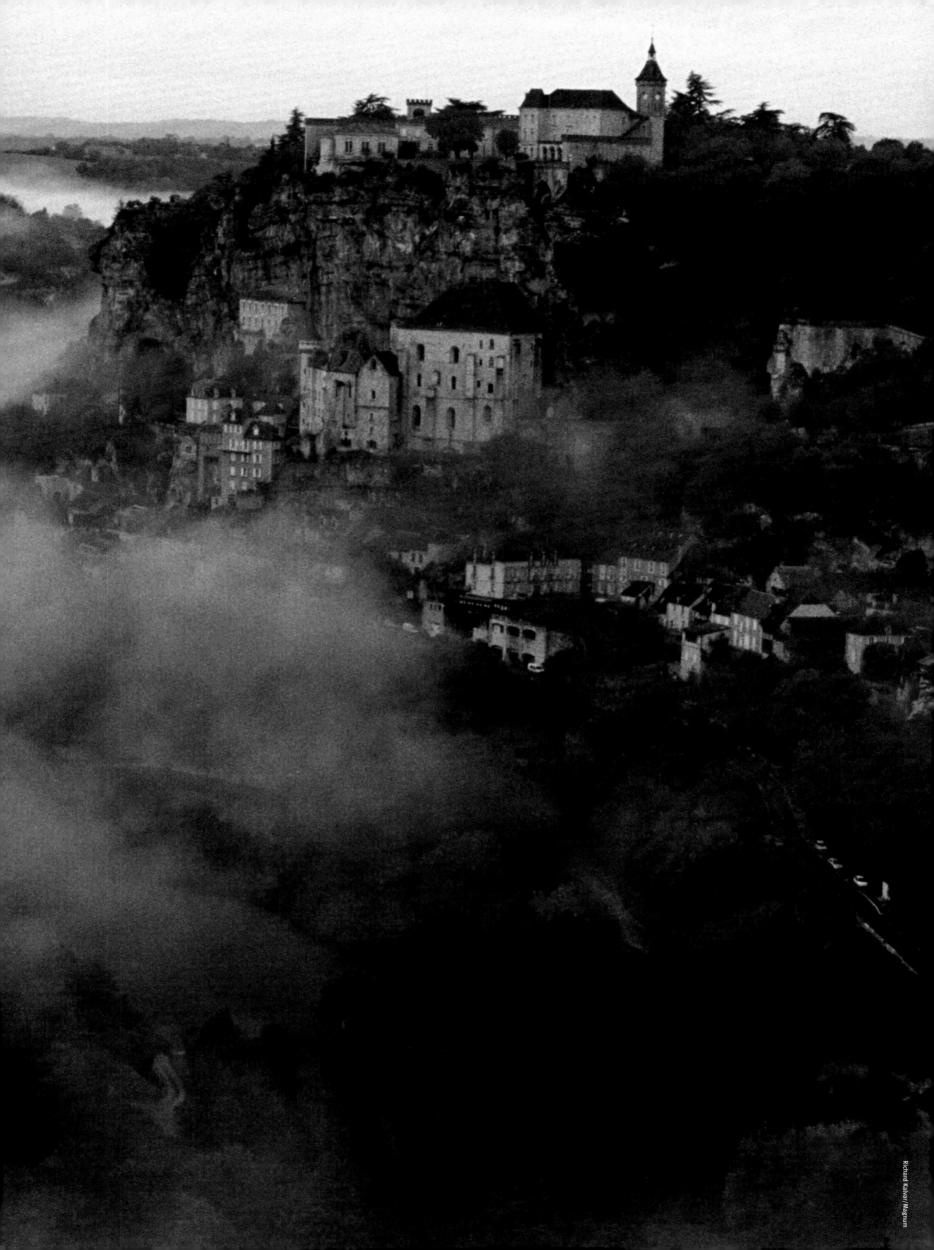

Cartagena

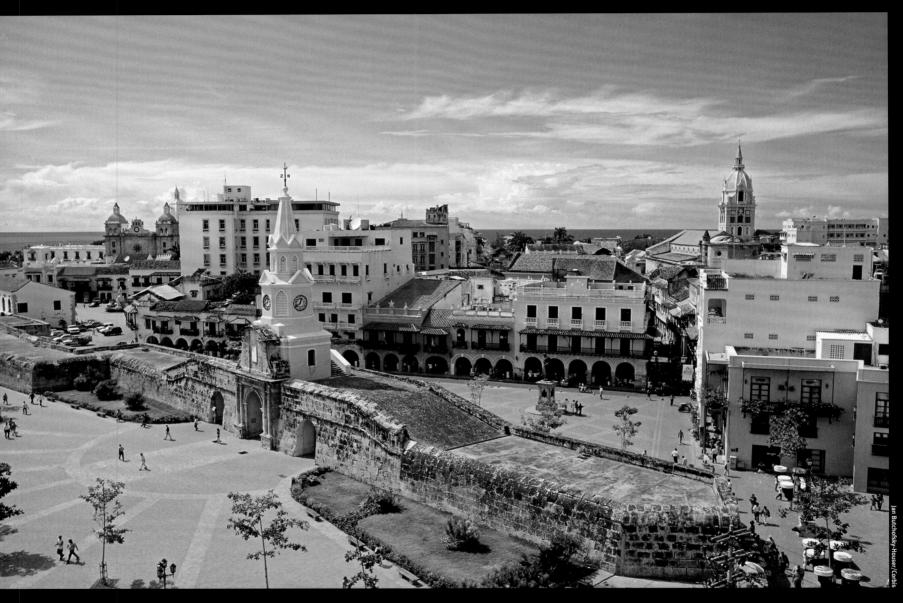

his seaport on the northern coast of Colombia is divided into the Old City and the New. The walled Old City (Ciudad Antigua), founded in 1533, is the charmer, a fishing village with tiled roofs, pastel buildings, beflowered courtyards, pleasant plazas and Spanish colonial architecture. Old fortresses and palaces make for interesting exploring, while for the sun 'n' fun crowd, the beaches are top-notch.

Krabi

A part of Thailand's superb coastal region was damaged terribly by the tsunami of 2004. However, even in a province like Krabi, parts of which were hit hard, restoration has been remarkable. Hat Rai Leh, seen here, is a glorious beach area that was left fairly unscathed. It has fantastic sea caves and cliffs carved out of limestone.

AL

Antibes

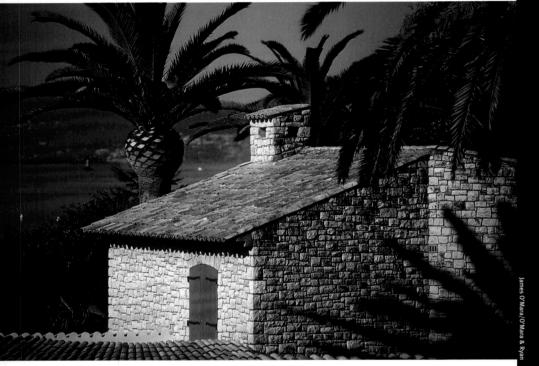

The French Riviera is certainly one of the most glamorous of destinations, and between Cannes and Nice can be found the most sparkling locale of all, Antibes. There are sundrenched beaches and secret creeks alongside streets lined with monuments fashioned out of honey-colored stone. Juan les Pins and its storied nightlife are part of the Antibes *commune*, as is Cap d'Antibes, a dreamy ultraluxury resort.

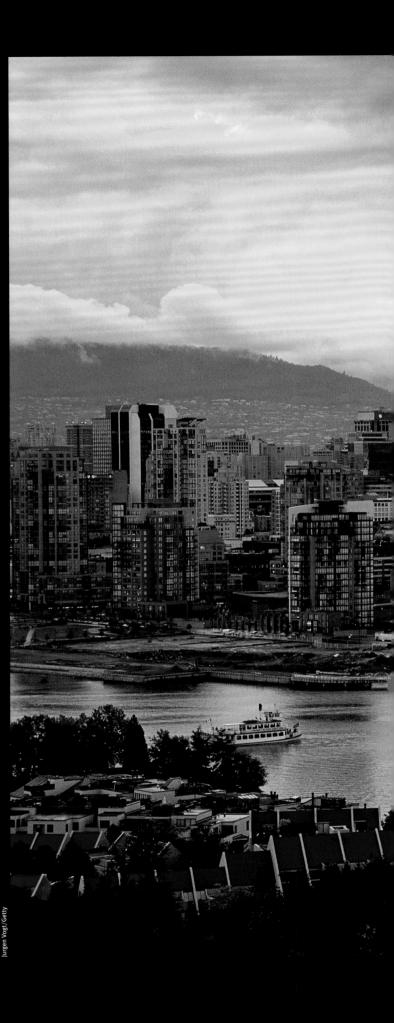

Vancouver

Image: With the set of the set o

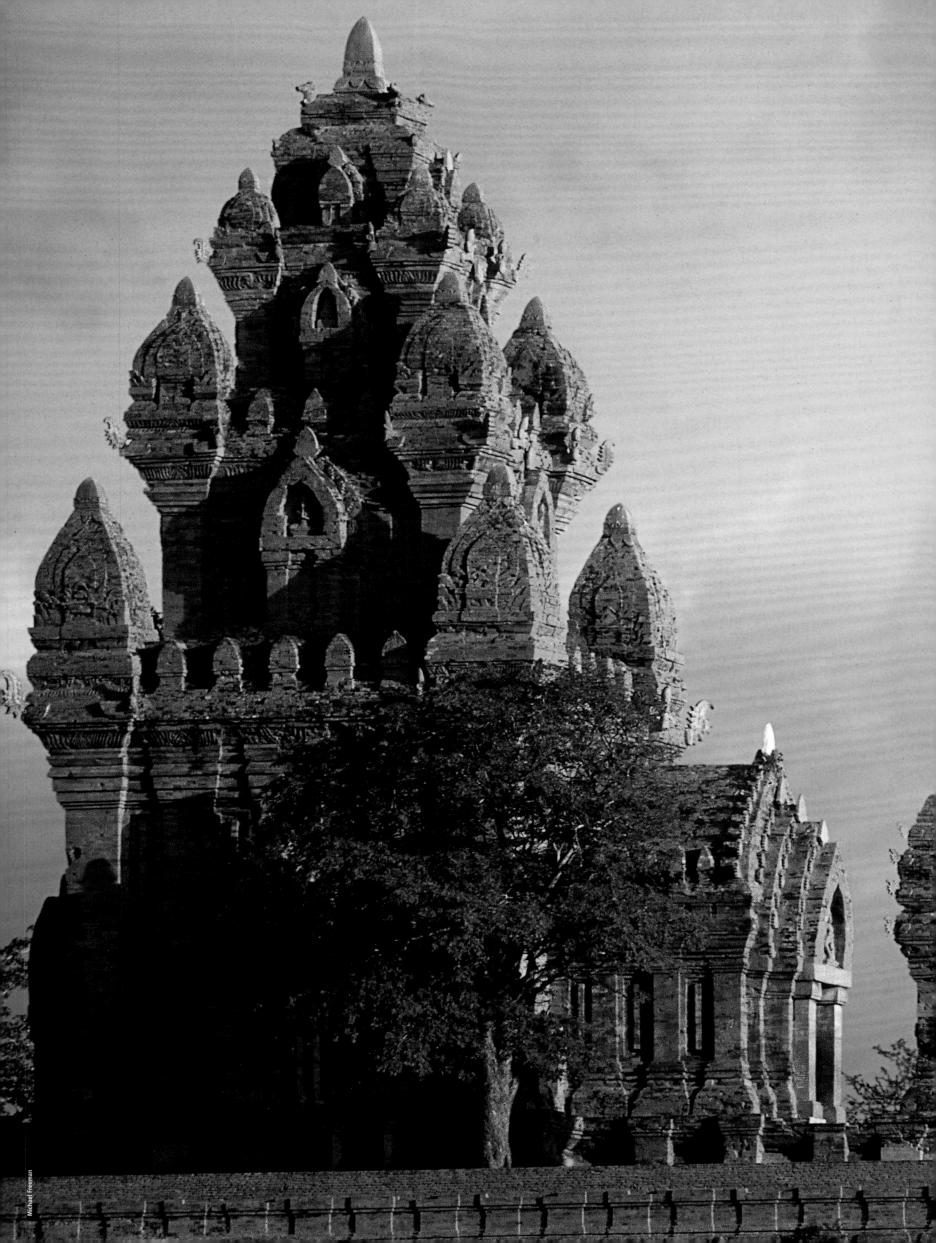

Phan Thiet

On Vietnam's southeast coast is a town that has relatively few tourists, but a lot of everything else. You can make your choice between an area of sensational sand dunes, and a long stretch of satisfying beach. Nick Faldo designed a golf course here that very well may be the best in the country. And there are older attractions, like the Cham Towers seen here, monuments that reside on a hill overlooking the town.

Registan Square

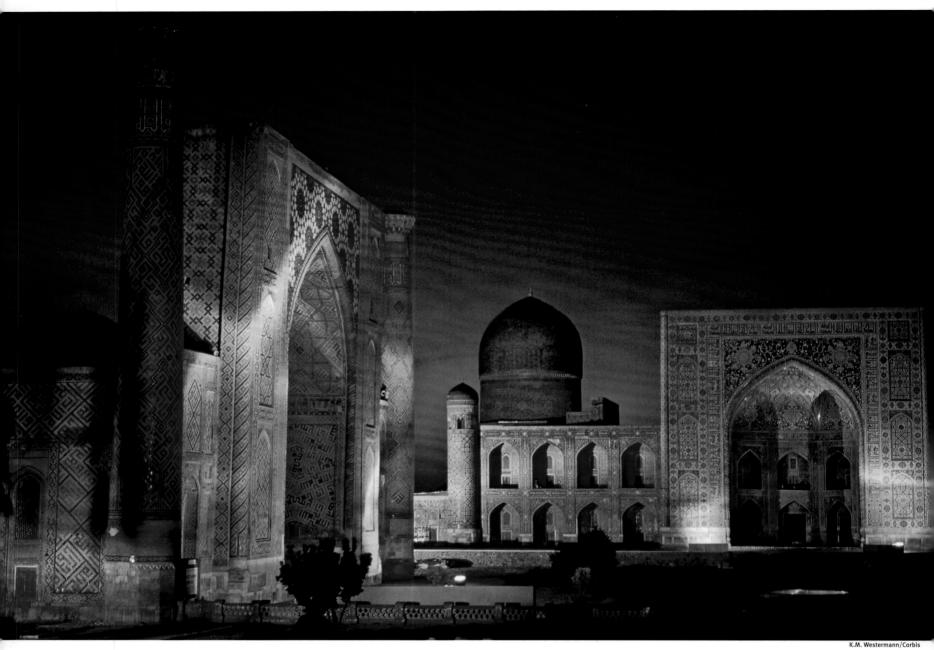

Samarkand is an old city in Uzbekistan, a central-Asian nation that broke free from the U.S.S.R. in 1991. What Lord George Curzon, then viceroy of India, said in 1899 maintains: "The Registan of Samarkand was originally, and is still in its ruin, the noblest public square in the world. I know of nothing in the East approaching it in massive simplicity and grandeur and nothing in Europe . . . which can even aspire to enter the competition."

One of Tibet's sacred lakes, Yamdrok Yumtso was created, according to legend, by the transformation of a goddess. This is not so hard to believe when one beholds the lake in summer. The water is turquoise blue, and its 309 square miles are fringed with pastures that make their way toward stately peaks. Tibetans compare the lake with the fairyland found in heaven.

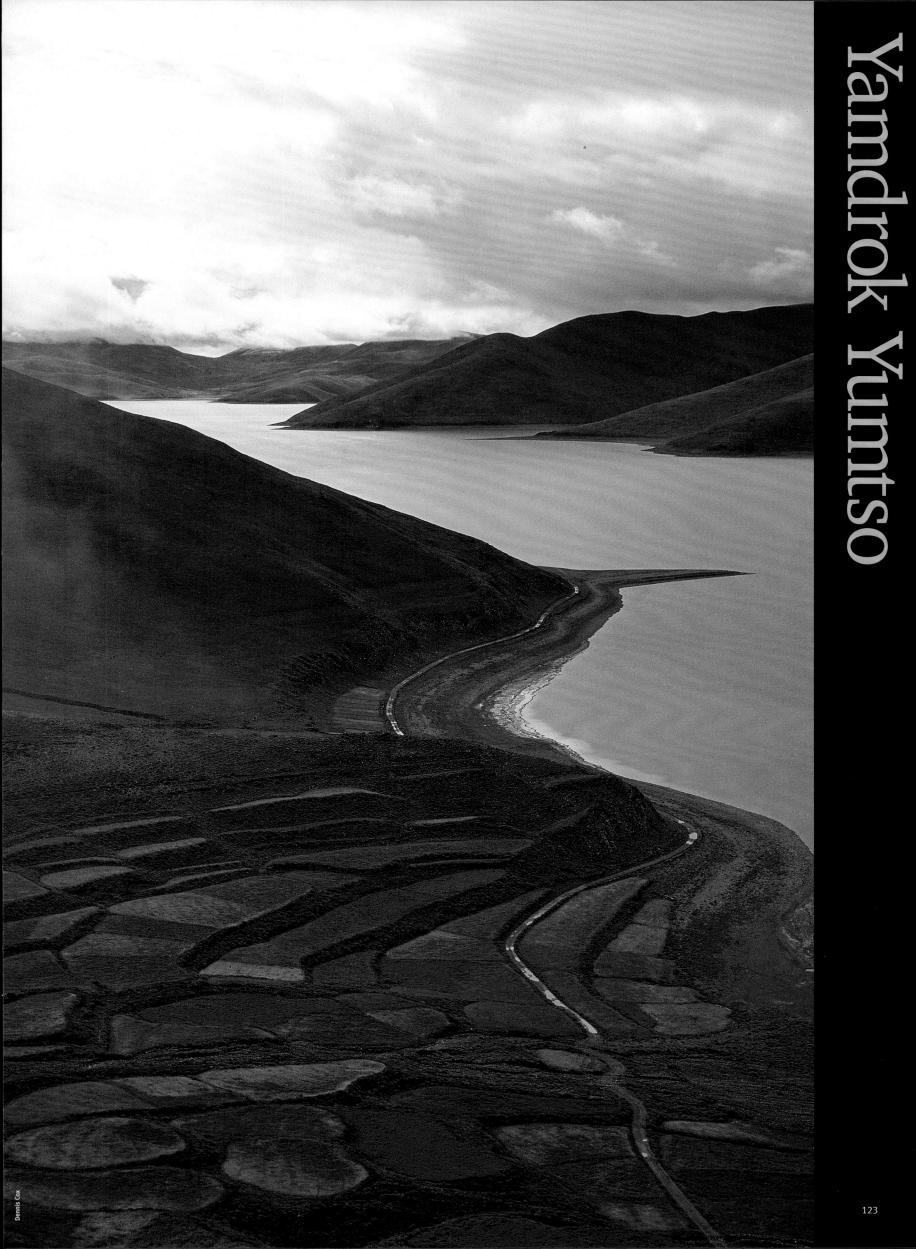

Budapest

Beautifully sited on both banks of the Danube, this Hungarian rhapsody provides two distinct precincts. To the west, Buda is gently hilly, with cobbled streets and architecture from a variety of periods. To the east, Pest is quite flat, with wide boulevards alive with commerce. Budapest is called The City of Spas because there are at least a dozen of them, drawing on medicinal waters issuing from underground thermal springs.

> From the 16th century until the end of World War I, this city on the Danube was the seat of the Holy Roman Empire and then the Habsburg Dynasty, and is today a repository of nobility and cultural achievement, notably in architecture and music. Whether you're sampling the churches or the pastry and the service in a Viennese restaurant is nowhere to be equaled—here is a locale to be savored at a leisurely pace.

Vienna

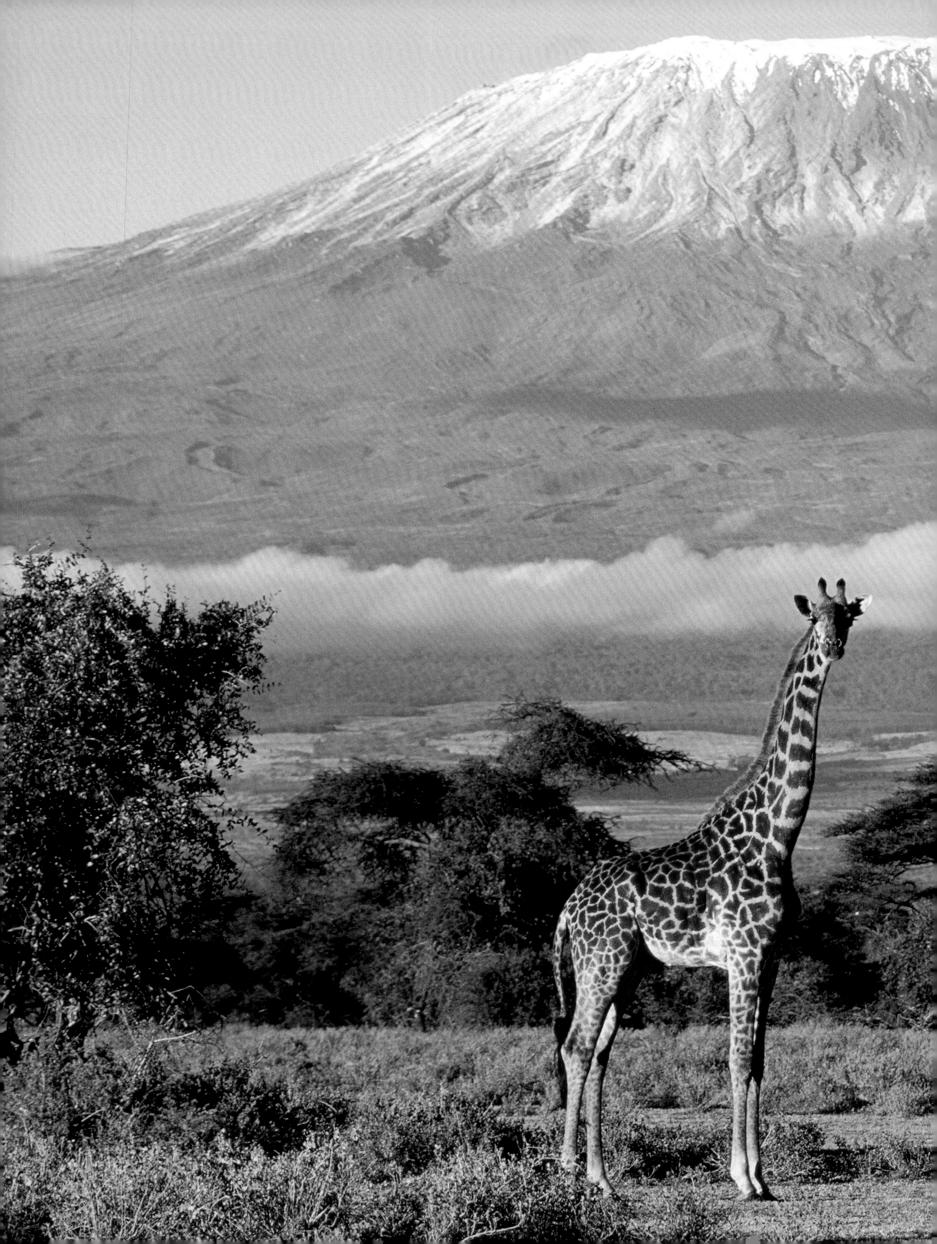

A h, Africa! What could be more exotic, more vivid, more passionate? And what says "Africa" more than Kilimanjaro? With its showy, snowy peak rising to 19,340 feet, the highest on the continent, Kilimanjaro makes the Rift Valley below tingle with mystique and adventure. Best of all, there is no need to be a great climber: This is the highest "walkable" mountain in the world.

Quebec City

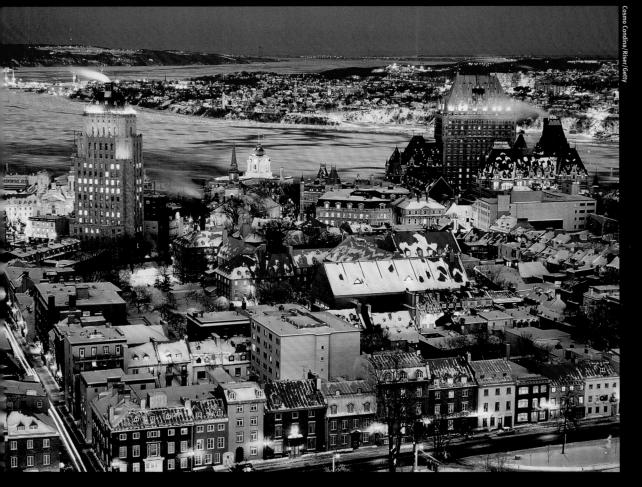

On page 111 we urged you to place Paris high on your bucket list, and that recommendation stands. But closer to home there is a metropolis of equal Gallic charm. Quebec is a province in eastern Canada, and its eponymous capital city is the center of all things French-Canadian. Take in the Citadel, the Basilica and the Chapel of Notre-Dame-des-Victoires, and sip champagne at the Chateau Frontenac hotel (pictured). *Magnifique*.

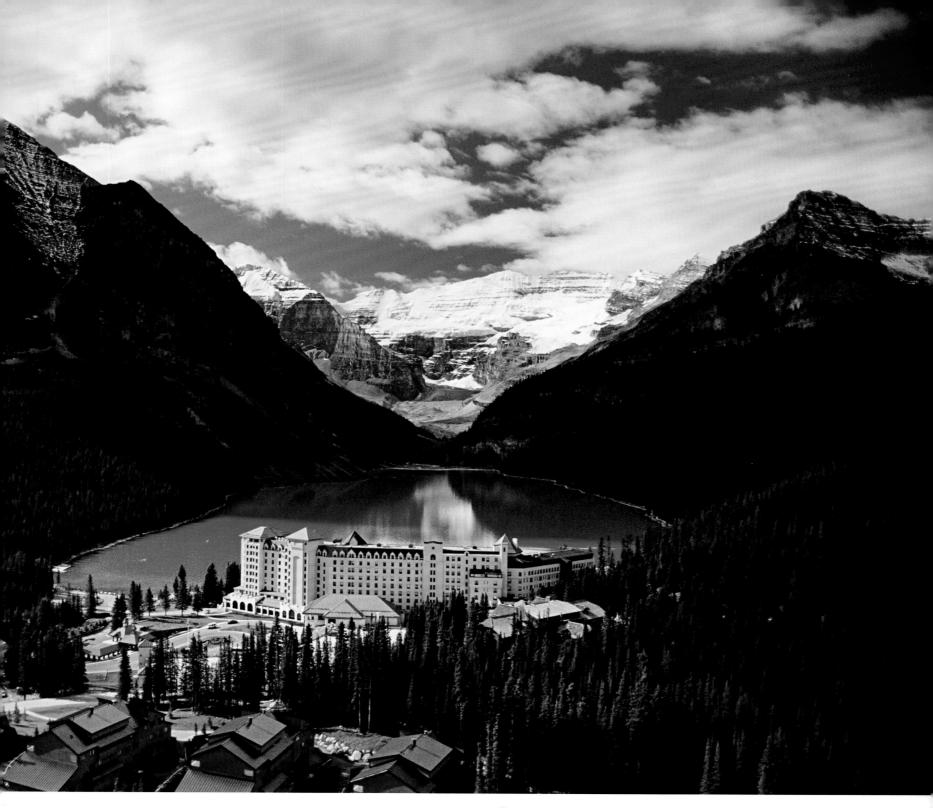

Canadian Rockies

A merica's Rockies are better than fair, but Canada's are better still. Winter or summer, they present a sensational venue for recreation, and the picture-perfect town of Banff, in Alberta, is the hub of all activity. If you have the wherewithal, by all means stay at either the legendary Banff Springs Hotel or the equally grand Chateau Lake Louise (seen here), which is up the mountain road a piece. Nice digs, eh? In French Polynesia lies a small island built by an extinct volcano and surrounded by a lagoon and a barrier reef. Coconut trees and azure waters are emblems of Bora Bora, as are naval cannons left over from World War II and, more pastorally, bungalows on stilts that peer over the lagoon. Nearby Tahiti is fine; Bora Bora is finer.

C-ISMANAR!

A. Star

Bora Bora

**

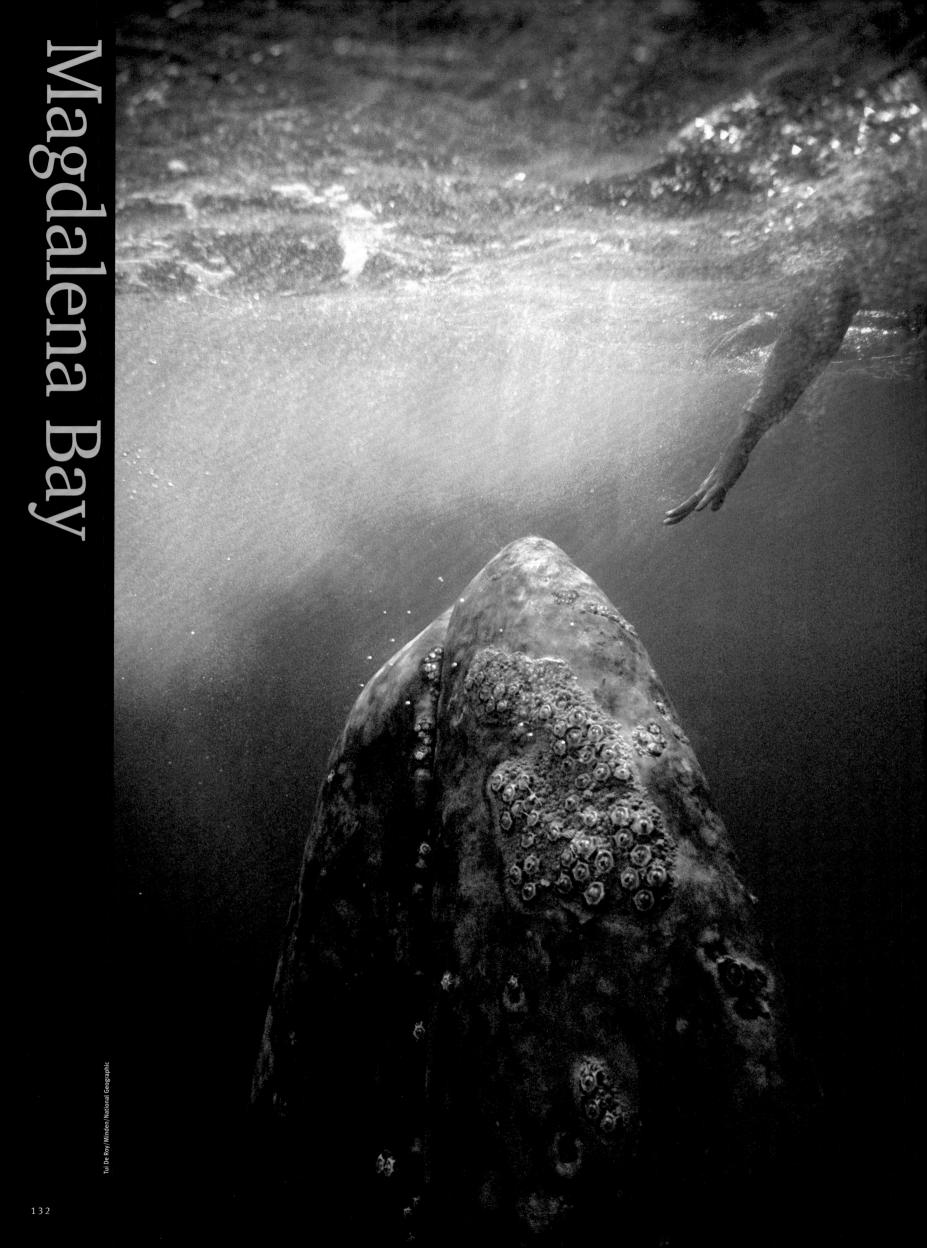

Winelands

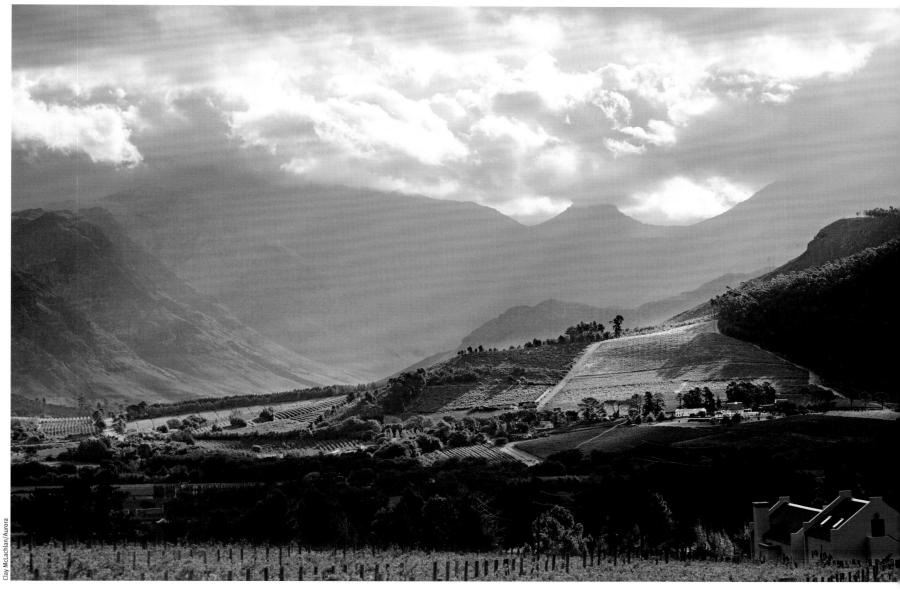

wo of life's great pleasures, mountain scenery and a sublime glass of wine, are often brought together in the world's great grape-growing regions. France, Italy, Spain, California, the Pacific Northwest, Australia, Chile, Argentina: Each boasts a precinct of vineyards as stimulating to visit as the product being produced is to sip. South Africa's Winelands in the high country of the western cape is the equal of any.

The 775-mile long Baja California peninsula in western Mexico is a fascinating realm of deserts and volcanoes and pine forests, historic Spanish missions and high-end spas. On the ocean side of the peninsula are three large bays, including this one, whose distinction derives from the gray whale. Having gestated 420 days, the southbound migrating females give birth here to 12-foot-long calves weighing more than a half ton, with whom humans can get up close and personal.

Cape Breton Island

This large island separated from the Nova Scotia mainland in eastern Canada by the Strait of Canso, yet connected umbilically by a causeway, is a world apart. This is the country of the pointed firs, with summer lake resorts and coastal fishing villages of the utmost charm. Wafting on the constant breeze is traditional Celtic music, imported along with Scottish refugees during the Highland Clearances of the 18th and 19th centuries.

his autonomous region in southern Spain—which boasts one of the most sublime climates in Europe, with plentiful summer sun attracts hordes of tourists to its coastal communities on the Mediterranean, particularly the famous Costa del Sol. But the smart visitor heads for the hills, too, where the remarkable "white villages" nestle in the Sierra Nevada.

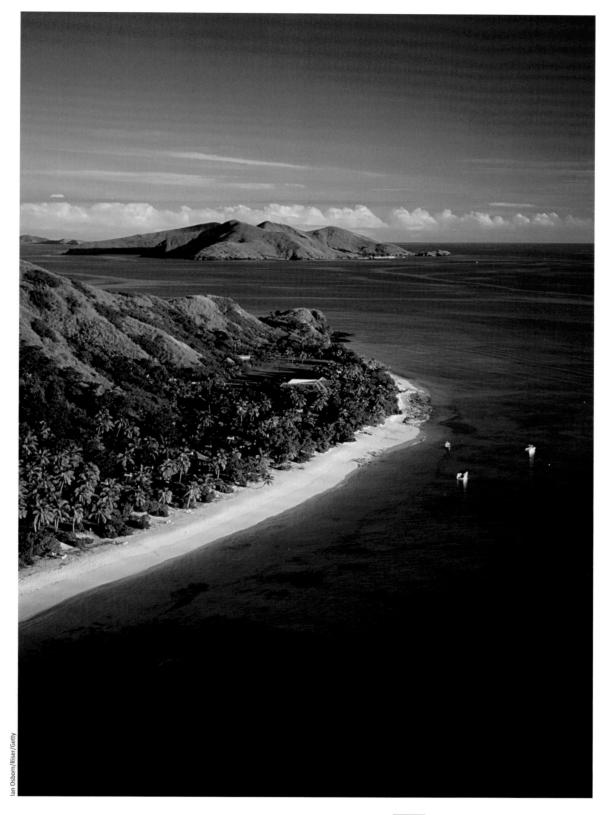

#Mamanuca Islands

The Fiji island group in the South Pacific comprises some 250 members, about 20 of which belong to the Mamanucas. Seven of these are submerged at high tide, but the remaining baker's dozen offer a tropical escape unlike any other. Tom Hanks thought so: It was on the Mamanuca island called Monuriki that he was *Cast Away* in the 2000 film.

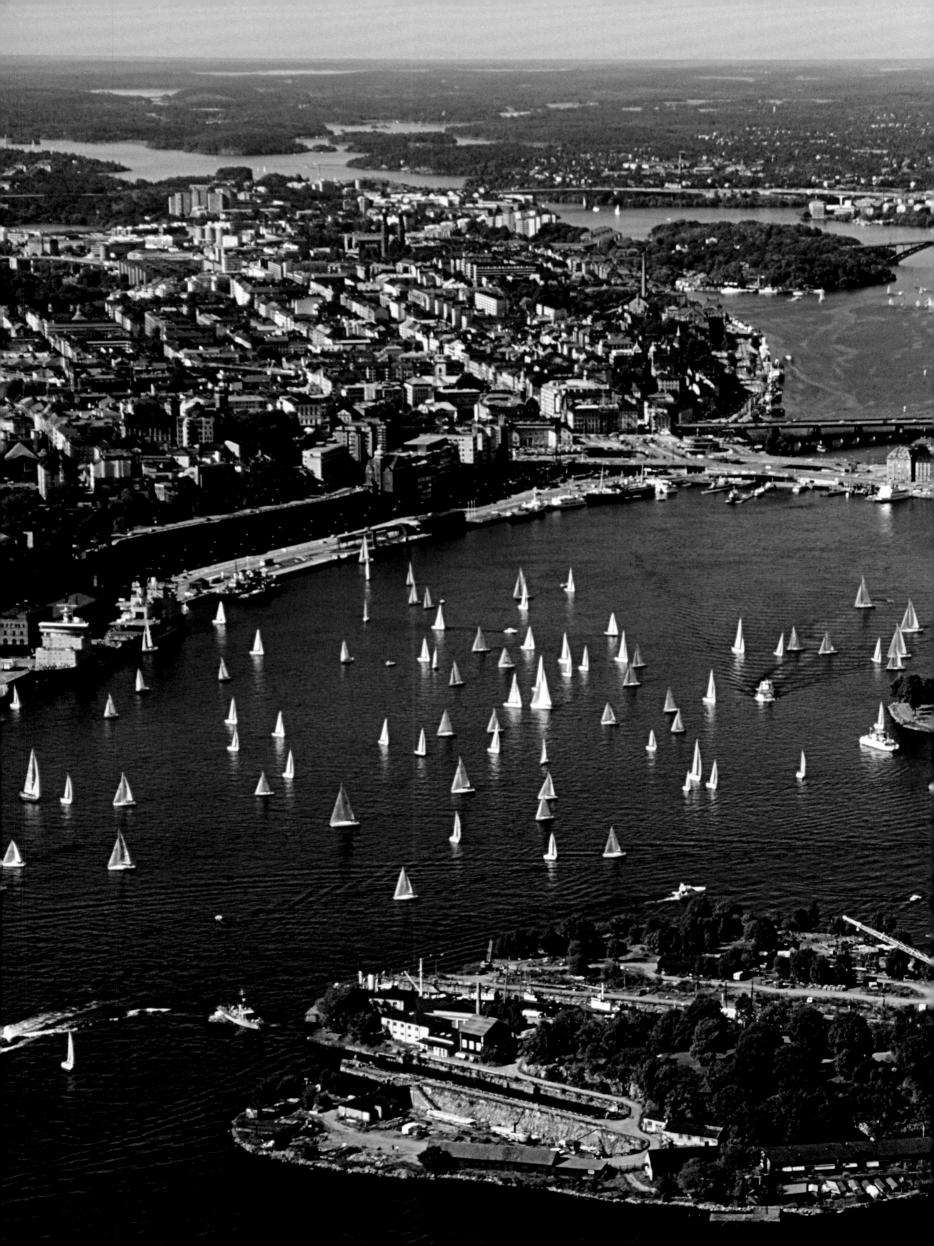

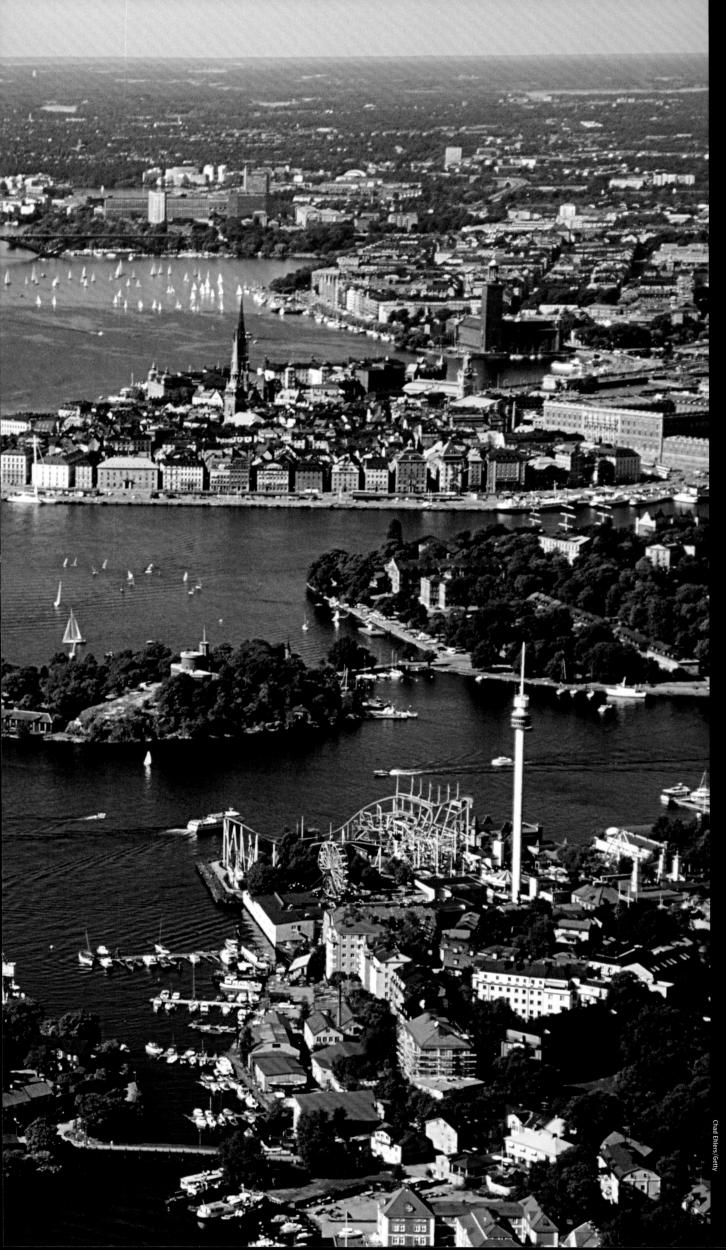

Stockholm

C weden's sensational Capital city is built on islands—14 of them—and the city's archipelago, which extends into the Baltic Sea approximately 40 miles, boasts 24,000 more isles and islets (yes, 24,000). In summertime, this wondrous metropolis, bathed in sunshine for 18 hours a day, is as radiant as any place on earth. There are some 50,000 vacation cottages sprinkled about-one just waiting for you.

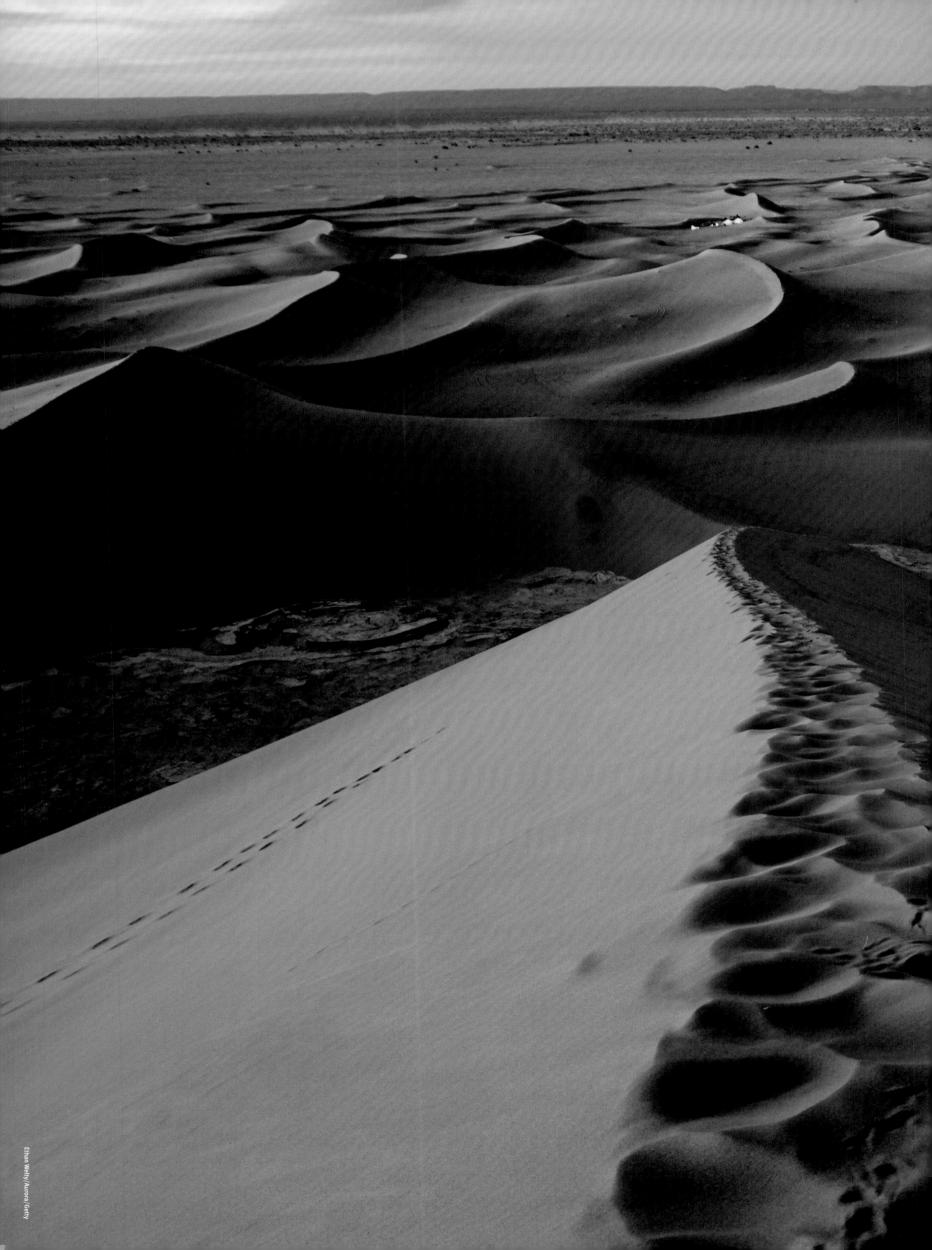

∃Sahara

In northern Africa, extending from the Atlantic to the Red Sea and from the Mediterranean to the Sudan, is the world's largest desert. Anything but a wasteland, it is the scenic home to the Atlas Mountains in the north, to depressions as much as 100 feet below sea level, to enormous sand dunes, to date-bearing oases adjacent to intermittent streams.

Isla de Vieques

E ight miles east of the Puerto Rican mainland in the Caribbean, extending a further 21 miles into the sea, is this spit of historical notoriety that represents, today, a paradise regained. Not long ago, protests against the U.S. Navy's use of the island as a bombing range were what one associated with Vieques. But the Navy left in 2003, and now the white sand beaches are regarded as among the best in the world.

Just One More

On the page immediately following there is a beautiful photograph suitable for framing taken by LIFE's Ralph Crane in 1962. It shows the Yosemite Firefall, which no longer exists, having been shut down by the National Park Service in 1968 as an unnatural event. It certainly was that. As early as 1872, campers and hotel guests atop Glacier Point would end their evenings by singing a final song, then pushing the cinders of their large campfires over the edge to the valley below. The initially spontaneous ritual became, through the decades, a big tourist attraction, and on special occasions—as in '62, when President John F. Kennedy was visiting—the fire was purposely enormous, and the Firefall was truly spectacular. We have seen, in our many previous pages in this book, wondrous natural and man-made spectacles than can be enjoyed today—and tomorrow. On page 144 we return to one of our *Heaven on Earth* sites and revisit a phenomenon that will never be witnessed again—except by you, when you frame this photograph, hang it on your wall and then fib to your friends that, sure, "I saw the Yosemite Firefall when I was a kid. It was *amazing!*"

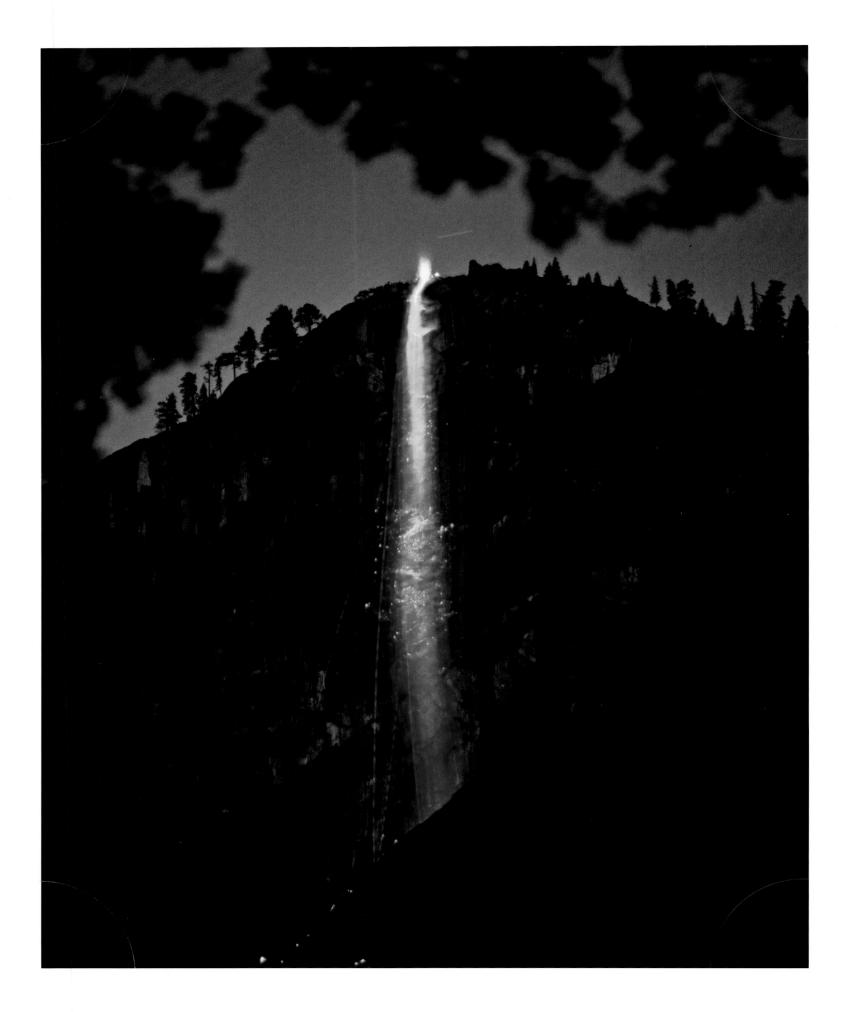

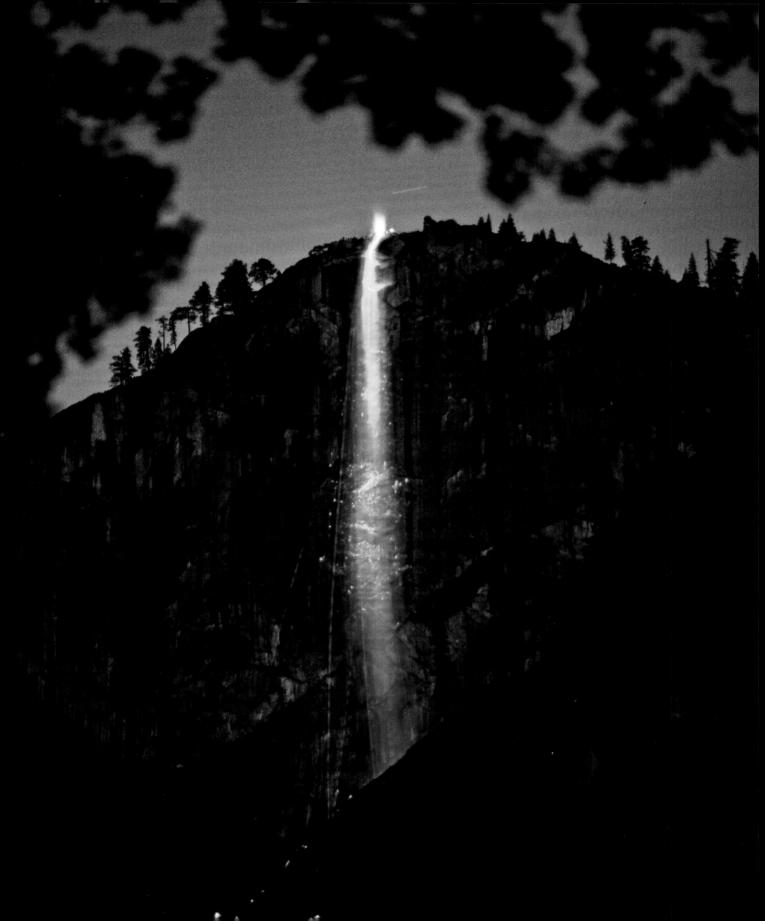

Firefall, Yosemite National Park, 1962 Photograph by Ralph Crane/LIFE® Time Life Pictures

LIFE, Heaven on Earth LIFE Books[®] 2011 Time Home Entertainment Inc.

For personal display only. All other uses, including copying or reproduction of this photograph or its image, in whole or in part, or storage of the image in any medium are expressly forbidden. Written permission for use of this photograph must be obtained from the copyright holder.

NORTH AMERICA

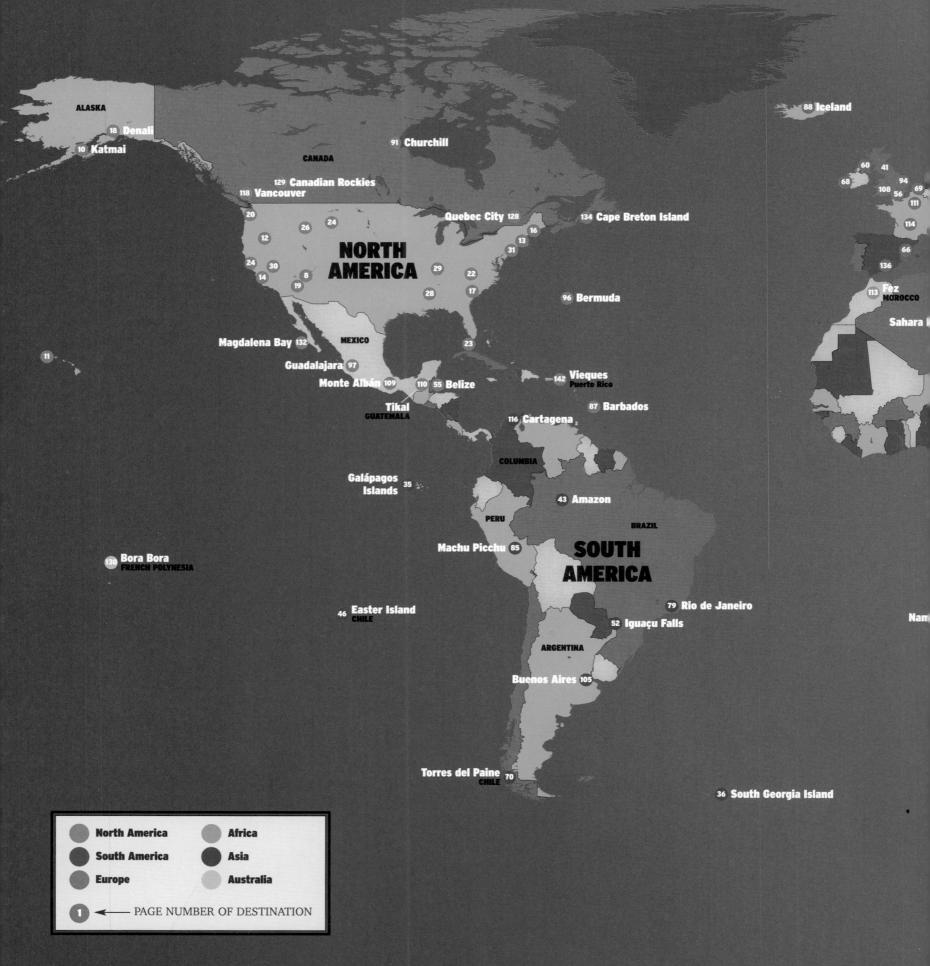